Seasons
in a
Country
Garden

Seasons
Country

FULCRUM PUBLISHING
Golden, Colorado

in a
Garden

Freda Cox

Library of Congress Cataloging-in-Publication Data

Cox, Freda.
 Seasons in a country garden / Freda Cox.
 p. cm.
 Includes bibliographical references (p.) and index.
 ISBN 1-55591-233-8 (hardcover : alk. paper)
 1. Gardening—Miscellanea. 2. Gardens—Miscellanea. 3. Cox.
Freda—Diaries. 4. Plants, Ornamental. 5. Plants, Ornamental—
Pictorial works. 6. Plants, Ornamental—Folklore. 7. Country
life—England—Shropshire. 8. Shropshire (England)—Social life and
customs. 9. Months—Quotations, maxims, etc. 10. English poetry.
I. Title.
SB455.C69 1995
635.9—dc20 95-30943
 CIP

Printed in Seoul, Korea
by Sung In Printing Company.

0 9 8 7 6 5 4 3 2 1

Fulcrum Publishing
350 Indiana Street, Suite 350
Golden, Colorado 80401-5093 USA
(800) 992-2908

To My Children
John, Kathleen, Mark, Camilla and Lorna,
who gave me the incentive to persevere.

And

For Sean
whose belief made it possible.

The following pages represent
a miscellany of eight journals completed over
a four year period of time.
The works are correct in their representation of time.

Table of Contents

Acknowledgements

I would like to thank all who have given me encouragement and help in the preparation of this book. Special thanks to my children, John, Kathleen, Mark, Camilla and Lorna (and Daniel) for wanting a journal each, thus giving me the incentive to persevere year after year! Then for their help and patience as the work progressed! Sean, for his encouragement and belief that it would be published and his efforts to that end. My mother, Catherine Rawlins, and my late father, Howard Rawlins (I miss you, Dad), with love and thanks. Leslie, Marita and James Rawlins for their efforts. Ann Casson and Liz Mason for helping me identify the unidentifiable. Clive Rawlins for first suggesting the journals could be published and for his valuable advice and support. Maggie Pearlstine for professional help, advice and kindness in the early stages. Daphne Brown for tremendous encouragement and all of her efforts on my behalf. Jan MacLeoud for pointing me in the right directions each time the computer blew up! R. and M. O. Gladwin for technical help. Alison Whittaker for extending my horizons and working so hard on my behalf. Chris and Barbara Warner of Warner's Roses for access to their beautiful flowers and Prof. A. D. Skelding, consultant curator of the Botanical Gardens, birmingham for help with the identification of Sambucus nigra f. viridus. My many friends, including Gretta and Maggie Cox, Dr. and Mrs. K. Brewser, the Rev. J. Donlan, Marianne Falk, Jean Groves, Barbara Handy, Sandra Humphries, Barbara Mason, Rosemary Rawlins, Mary Rolleston, Pauline and Ian Tomson, Penny Westgate, Geoffrey Westgate, the Rev. Mother and all Sisters at the monastry of Poor Clare Colettines, Ellesmere and all other friends and relatives too numerous to mention for their help, advice, support, friendship and encouragement.

Special thanks to everyone at Fulcrum Publishing for their hard work and great kindness, particularly Bob and Charlotte Baron, Carol Clark, Steve Garvan and Donna Hamilton.

Last, but certainly not least, very special thanks to Jay Staten of Fulcrum for all of her hard work, patience, perseverance, kindness and understanding, her great professional talents and artistic flair in bringing this book to life.

Introduction

I was born in 1942, though remember nothing of the horrors of the War Years. Sitting in a shelter beneath the dining room table was a game.

My first memories of flowers began early. Picking flowers from the garden for my new brother when I was two years old, followed by going out solo, collecting large handfuls of blooms from local front gardens! Not to be encouraged!

Our next garden seemed immense. Acres and acres of tussocky grass, wild growing raspberry canes and apple trees. Today it would probably appear about 20-foot square! In those days it was adventure and a trek to the bottom of the garden could take half a day with all the mysteries it held.

I had a little patch in one corner but the flowers I planted were mainly plucked from other parts of the garden, without roots. I was always bitterly disappointed when they shriveled and died. I remember making flower chains, which also died. Moulding a "bird's nest" from mud and grass, pushing tiny flowers and petals between the grass stems to make it "pretty" for the birds. A precipitous climb into the branches of the old apple tree to position the nest proved unnecessary—no bird ever came along to take up residence.

School brought lessons in painting. The teacher seemed ancient but his words, always remembered: "LOOK at what you are painting, don't just draw what you think it's like—Look, Look, Look." I did look and saw that the leaves of my bluebell did not start halfway up the stem!

Flowers attracted me in all their various forms. Wilted, petal-dropping bunches from the local market; beautiful florist full of expensively exotic blooms. Soft, purple petalled violets from the flower lady on the corner, conjured up romantic visions of girls, like me, walking the fields and lanes of Devon and Cornwall to pick dew-drenched violets for the city.

I was ten when we moved to Shropshire, where I found whole banks of violets in various shades of blue, purple, pink and white. Deep ditches held the first pale Primroses while Cowslips scattered sheets of gold, and an acre of mowing grass was always covered with thousands of Early Purple Orchids. Later the lanes would be bordered with pink patches of Spotted Orchids, and what excitement when a Twayblade appeared in the dappled shade of Beech trees! However, jealousy was roused when a friend took a Bee Orchid to school, found on the hills above Cheddar Gorge. I could not believe how perfectly it resembled an actual bee and vowed and declared that I too would find Bee Orchids.

When pressed flowers faded to a uniform brown, I decided to paint them instead, while a school trip to Switzerland opened unbelievable horizons of alpine flora. Deep blue Gentians and Pulsatilla Anemones on the slopes above Zermat and the wonder of finding my whole plate surrounded by a wreath of mountain flowers on my tenth birthday, which fell while I was there.

It was important to me that the drawings were accurate reproductions of the plants I saw, and a year at Art College proved a total disaster. They insisted on a freer, more fluid style, and we soon fell out.

Married with children, the painting continued. Pictures were included in exhibitions and sold. Solo exhibitions around the country followed, and pictures were reproduced for greetings cards. Entering the commercial field, I worked on textile and porcelain designs. Anything, in fact, that involved flowers.

It could not be said that I led a peaceful life by any means, but somehow, with all the traumas, I survived and continued to paint.

Trips abroad have always been spent painting the local flowers. A visit to Ireland in 1986 resulted in a small notebook recording both the holiday and the flowers found there. This idea developed, resulting in two volumes of plants and flowers from my four-acre garden, with botanical notes, snippets of folk and plant lore and pieces of favorite poetry.

My children decided I should continue the theme so they could each inherit their own, hand-painted sketchbook. With five children, this meant a great deal of work!

Living in a comfortably rambling old farmhouse, I now concentrate on painting, writing and gardening. The children come and go, bringing a succession of friends. The dogs keep me active, while the cats sleep outside in the sun, or inside, by the Aga, depending on the season. Five ducks rule the yard, though they would much prefer to be in the kitchen. Watching their antics is better than television anyday. They too have a passion for flowers in the garden—to eat—such is life!

"*There's rosemary,
that's for remembrance;
pray, love, remember;
and there is pansies,
that's for thoughts.*"

—William Shakespeare
1564–1616

January is named after the Roman God Janus. He had two faces—one looking back over the old year and one looking forward to the new. It was called 'Wolf-monath' by the Anglo Saxons, when hungry wolves preyed on the villages.

"If January's calends be summerly gay, 'twill be wintery weather to the calends of May."

January

"A January spring is worth nothing."

"If the grass do grow in Janiveer, it grows the worse throughout the year."

"If the birds begin to sing in January, Frosts are on the way."

"March in January January in March."

"The blackest month of all the year is the month of Janiveer."

"Janiveer—Freeze the pot upon the fire."

"A wet January—a wet Spring."

New Year's Day used to be March 25th until the Gregorian Calendar was accepted in 1752. January 1st commemorates the circumcision of our Lord and the solemnity of Mary, mother of God.

The first water drawn from any well on New Year's Day was called the 'Flower of the well'.

New Years Day

The first recorded New year's Festival is that constituted by Numa - 713 B.C. - and dedicated to Janus.

"First Footing" ~ After the last stroke of midnight on New Years Eve has died away, the first person to enter the house should be a dark-haired, unmarried man, whose eyebrows do not meet in the middle. He must carry a piece of coal to symbolise fire and light, a piece of silver to symbolise wealth and a piece of bread to symbolise food. In some areas a fair-haired man is preferred, while if a woman is the first to enter the house, it is said to bring bad luck. Farmers would sometimes take a sprig of mistletoe to the first cow that calved in the New Year as they thought it would bring luck to the rest of the herd.

3

1987

<u>January 1st.</u>

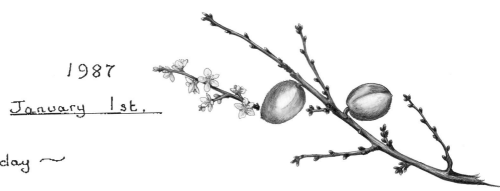

New year's day ~

The showers of the early morning eventually turned to
torrential rain. The river Mease has started to flood
and is spreading across the fields at the back. It is
still quite mild though and there are little patches of
colour all round the garden. There are even roses
still in bloom and the hedge of iceberg roses is
covered in buds, the white flushed with pink now
from the rain.
Collected a colourful bouquet from the garden which
looked more like spring than the first day of the year.
The absence of too many frosts so far this winter has
meant the spring flowers are coming into bloom early, while
last years flowers linger on.
The snowdrops are poking through and just showing
white and in the wood I found the prunus
autumnalis in full flower ~ the first year it has
bloomed and the delicate white and pink of the
little flowers really brightened up the dull day.
The Christmas roses are only just showing though
and have been beaten this year by the Lenten
rose which has a deep purple bud ready to break
into flower.
All along the edges of the borders the polyanthus
are covered in flower, white, cream, lemon, deep
yellow, pink, red, purple and deep blue, such a range
of colours for the very first day of the new year!

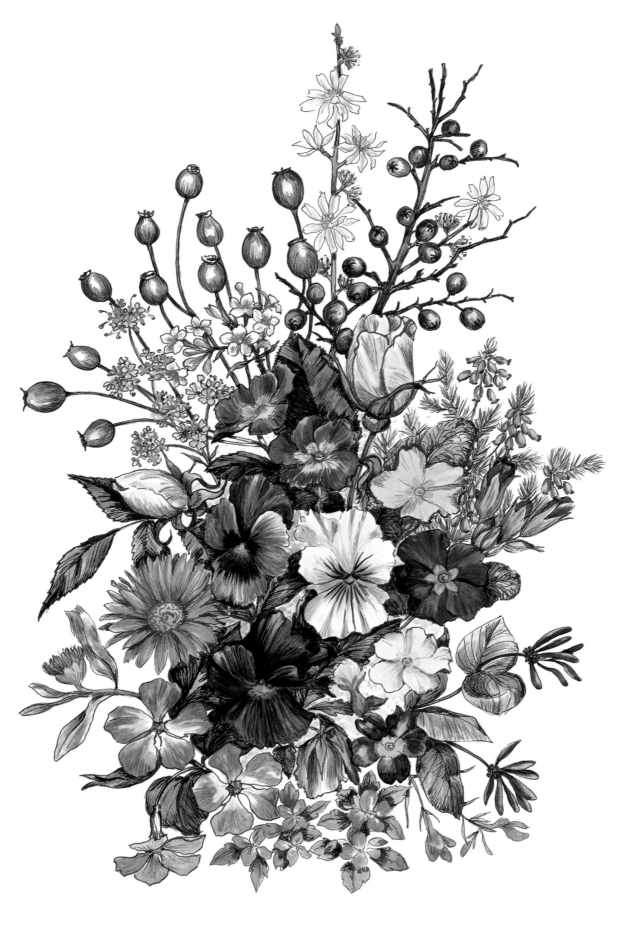

A Winter Bouquet.

3rd January

The prunus subhurtilla autumnalis ~ winter flowering cherry is fully out and covered in blossom in St. Mary's Churchyard in Shrewsbury. Also saw a bush of hazel catkins well advanced in a sheltered corner.

First thing in the morning,
there are crowds of small birds after the rose-hips in the hedge at the back. A very windy start to the New Year and plenty of rain. The weather in January is very unreliable It can be very cold or reasonably warm An old proverb states, "Winter weather and womens' thoughts often change."

The New Year

He was the one man I met up in the woods
That stormy New Year's morning; and at first sight,
Fifty yards off, I could not tell how much
Of the strange tripod was a man. His body,
Bowed horizontally, was supported equally
By legs at one end, by a rake at the other:
Thus he rested, far less like a man than
His wheel-barrow in profile was like a pig.
But when I saw it was an old man bent,
At the same moment came into my mind
The games at which boys bend thus, 'High-cockolorum'
Or 'Fly the garter', and 'Leap-Frog'. At the sound
Of footsteps he began to straighten himself;
His head rolled under his cape like a tortoise's;
He took an unlit pipe out of his mouth
Politely ere I wished him 'A Happy New Year,'
And with his head cast upward sideways muttered—
So far as I could hear through the trees' roar—
"Happy New Year, and may it come fastish too",
While I strode by and he turned to raking leaves.

Edward Thomas

1st January 1915.

wherever decaying vegetable matter exists, we may expect to find a new race flourishing among the debris.

January 2nd.

Dull and much colder, the strong winds bringing icy blasts direct from the Arctic. Found a spray of cow parsley in full bloom in the wood.

Cutting up an old pine tree for wood and in the log shed, found a dry log covered with hundreds of tiny toadstools and spores.

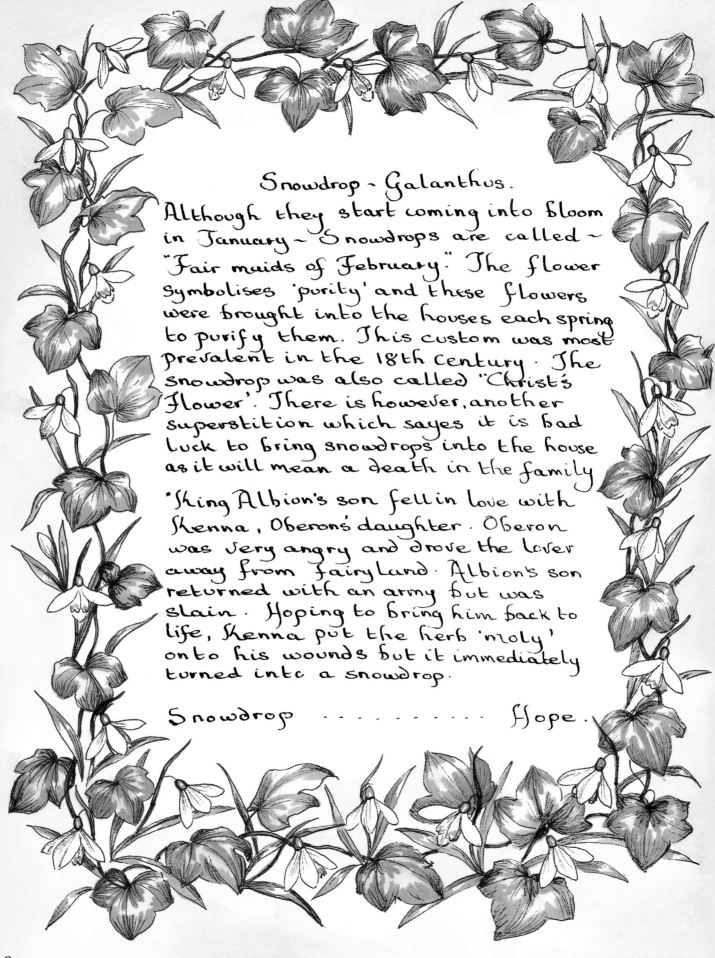

Snowdrop - Galanthus.

Although they start coming into bloom in January - Snowdrops are called - "Fair maids of February." The flower symbolises 'purity' and these flowers were brought into the houses each spring to purify them. This custom was most prevalent in the 18th century. The snowdrop was also called "Christ's Flower". There is however, another superstition which sayes it is bad luck to bring snowdrops into the house as it will mean a death in the family

"King Albion's son fell in love with Skenna, Oberon's daughter. Oberon was very angry and drove the lover away from fairyland. Albion's son returned with an army but was slain. Hoping to bring him back to life, Skenna put the herb 'moly' onto his wounds but it immediately turned into a snowdrop.

Snowdrop Hope.

Winter Jasmine - Yellow Jasmine -
Jasminum nudiflorum - Oleaceae

Weak, woody stemmed shrub of sprawling habit bearing bright yellow flowers throughout the winter. Jasmine originated in China and was introduced by Robert Fortune in 1844 Although the flowers can suffer from frost damage, they are soon replaced.

Jasmine. Grace and Elegance.

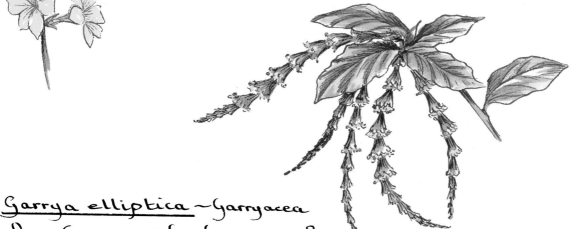

Garrya elliptica ~ Garryacea
An evergreen shrub grown for its attractive catkins in winter and spring. The male plant carrys longer and more attractive catkins. Oval, wavy-edged, dark green, leathery leaves with very long, grey-green catkins with yellow anthers.

Winter aconite - Eranthis hyemalis - Ranunculaceae
A tuberous perennial flowering late winter - spring and having cup-shaped, bright yellow flowers surrounded by a ruff of dissected, leaf-shaped bracts, beneath the flower.

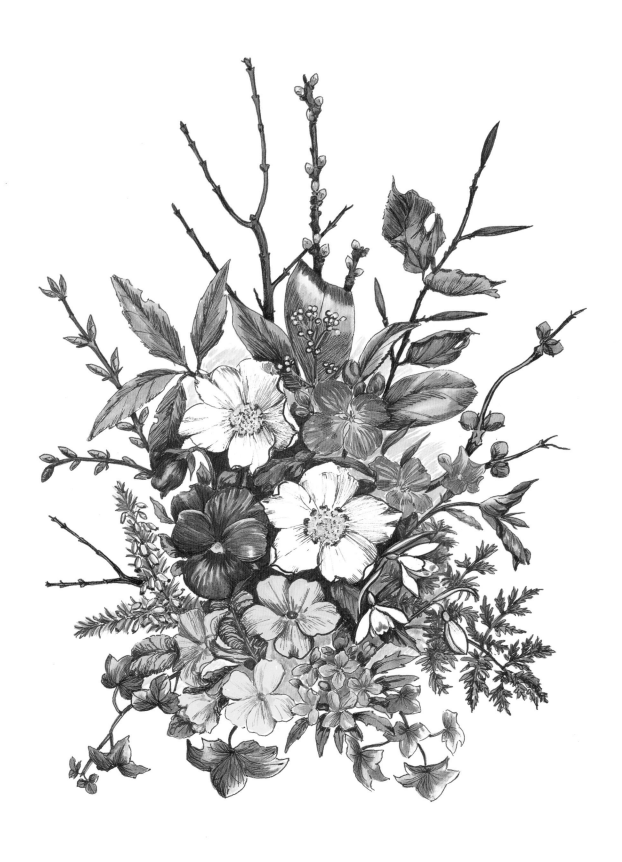

'After The Snow'

10

6th January ~ Epiphany

Beautifully clear and sunny day, blue sky and not too cold. The blackbirds are having a feast on the windfall pears still left under the tree. It is still very dark at 7.30 in the morning but today, in the darkness, a thrush was singing.

Epiphany ~ from the Greek, meaning 'manifestation' - It refers to the revealing of Christ to the three wise men.

Twelth Night

Twelth Night, or old Christmas Eve, falls on January 5th. The Christmas decorations are taken down and at one time, there used to be plays and parties and great celebrations. Shakespeare wrote "Twelth Night" for the occasion. It marks the formal end to Christmas, which falls on 6th January ~ Epiphany ~

> " Then came old January, wrapped well
> In many weeds to keep the cold away
> Yet did he quake and quiver like to quell
> And blewe his nayles to warm them if he may;
> For they were numbed with holding all the day,
> An hatchet keene, with which he felled wood
> And from the trees did lop the needlesse spray."
>
> E. Spenser
> 'Faerie Queen'

Plough Monday

The first Monday after Epiphany is 'plough Monday'. It was the traditional day for the ploughmen to return to work and the ploughs were blessed on this day.

"Wassailing Time"

At this time of year the apple orchards used to be 'Wassailed'. The word 'Wassail' comes from the Anglo-Saxon Wehāl, which means 'be of good health'. After dark, the farm workers and their families went to the apple orchards, carrying shot guns, horns and a pail of cider. The cider was poured round the roots of a chosen tree and a piece of toast or cake, soaked in cider was placed in the branches while a wassailing song was sung to the tree asking for a good crop.

January 19th

To Manchester. The clear whiteness of the snow is fast disappearing with the industrial grime. The motorway was busy with lorries ferrying goods from all parts of the country and even the Continent. Saw some big flocks of seagulls. They have become much more common inland over recent years. Now, it is an everyday occurance to see as many gulls feeding on the ploughed fields of the Midlands as on the coastline.

January 20th

The thaw has really set in and there is a steady drip, drip from the melting snow and icicles.

January 21st

Manchester again. Snow nearly all gone but very foggy today. Walked round the garden this morning and where the snow has gone, there are green shoots pointing through everywhere. Daffodils and bluebells coming and the snowdrops are very nearly out and showing plenty of white.

January 26th

Australia Day! Not too cold today. Three lovely cock blackbirds on the lawn hunting for food. One found an enormous worm and nearly fell over backwards trying to pull it out. The weather forecast this evening said Bristol has created a new record by not having any sun for 13 days!

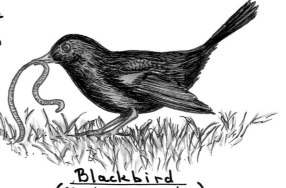

Blackbird
(Turdus merula)

male, all black with yellow bill and yellow eye ring. Female dark brown above, paler below with indistinctive dark mottling. One of the most abundant European birds. Originally a forest dweller, it has greatly increased its population by adapting to suburban conditions, where short grass provides ideal foraging for worms and food. Also eats berries and fruit.

January 27th

Managed to pick quite a presentable bunch of flowers from the garden though there is not as much in flower as there was before the snow and everything has taken quite a battering. Things are moving however, new buds on the polyanthus, snowdrops pushing through everywhere and daffodil shoots coming through fast. The little Christmas Rose is still producing more flowers and the buds on the almond tree are just flushed with pink.

January 28th

In 1809, on this day, Pall Mall became the first street of any city to be lit by gas ~

Awoke to brilliant sunshine and a light frost. The garden is filled with expectant bird song, all thinking spring is on the way. Went into Birmingham and exactly at dusk, the sky was suddenly filled with a

Starling
(sturnus vulgaris)

moving, black cloud of starlings which descended in a screaming, chattering mass onto all the trees and buildings. An amazing sight and sound. People who were obviously used to this nightly invasion put up umbrellas but all the others had to run the gauntlet!

13

February, the second month of the year. The Latin Februo, to purify by sacrifice ~ The month of purification amongst the ancient Romans.

It is said if the weather is fine and frosty at the close of January and begining of February, we may look for more winter to come than we have seen up to that time.

"All the months of the year curse a fair Februeer"

February

February brings the rain,
Thaws the frozen ponds again.

"February fill dyke, Be it black or be it white."

In the month of February,
When green leaves begin to spring,
Little lambs do skip like fairies,
Birds do couple, build and sing.'

February has twenty eight days except in a leap year when it has twenty-nine.

In February, if thou hearest thunder,
Thou shalt see a summer wonder.

If February bring no rain, 'tis neither good for grass nor grain.

February

One month is past, another is begun,
Since merry bells rang out the dying year,
And buds of rarest green began to peer,
As if impatient for a warmer sun;
And though the distant hills are bleak and dun,
The virgin snowdrop, like a lambent fire,
Pierces the cold earth with its green-streaked spire
And in dark woods, the wandering little one
May find a primrose.

Hartley Coleridge ~ February 1st 1842.

Candlemas Day

The feast of the purification of the Virgin Mary when Christ was presented by her in the Temple. February 2nd., when, in the Roman Catholic Church there is a candle procession to consecrate all the candles which will be needed in the Church during the year. The candles symbolise Jesus Christ, called "The Light of the World" and "A light to lighten the Gentiles". It was the old Roman custom of burning candles to the Goddess Februa, mother of Mars, to scare away evil spirits.

"On Candlemas Day, candles and candlesticks throw away."

"On Candlemas Day, if the thorns hang a-drop,
Then you are sure of a good pea crop."

"If Candlemas Day be dry and fair,
The half o' winters come and mair;
If Candlemas Day be wet and foul
The half o' winter has gane at Youl."
~ Scottish proverb ~

"The badger peeps out of his hde on Candlemass Day, and, if he finds snow, walks abroad; but if he sees the sun shining, he draws back into his hole."
~ German proverb.

15

14th February

St Valentine's Day

The day when lovers exchange tokens of their affection.

Valentine is a corruption of 'galantin ~ a lover ~ a dangler ~ a gallant.

St Valentine was chosen for the sweetheart's Saint because of his name but in actual fact, there are over fifty saints called Valentine and as two of them were martyred on this date, no-one is quite sure which one the day actually honours! Some say it was the Christian martyr under Emperor Claudius c.270, the St. Valentine who was beheaded on this day but perhaps the day honours both. The custom of exchanging love tokens on this day is not associated with St. Valentine but was a practice associated with the worship of Juno.

Some say traditionally the birds will have mated by 14th February, though others say the birds will begin their courtship and find their partners on St. Valentine's Day ~ Certainly the bird ~ song begins in earnest now.

This day is also the start of the Salmon fishing season on the River Tweed. The boats, nets fishermen and river are blessed and after the ceremony, the first boat of the season is launched.

Millions of cards are now exchanged on Valentine's Day. In Victorian times romantic, lacy cards were all the rage. Glamour was the hallmark of the twenties and thirties but today's cards cover the whole range from lavish hearts, delicate Victorian reproductions, cute and cuddly animals, saucy rhymes and even very naughty cards!

"And the Lady Fair of the Knight so true
Remembered his
helpless lot,
And she cherished the flowers of brightest hue,
And braided her hair with the blossoms blue
And called it Forget-me-Not"

: Old Valentines Verse.

17

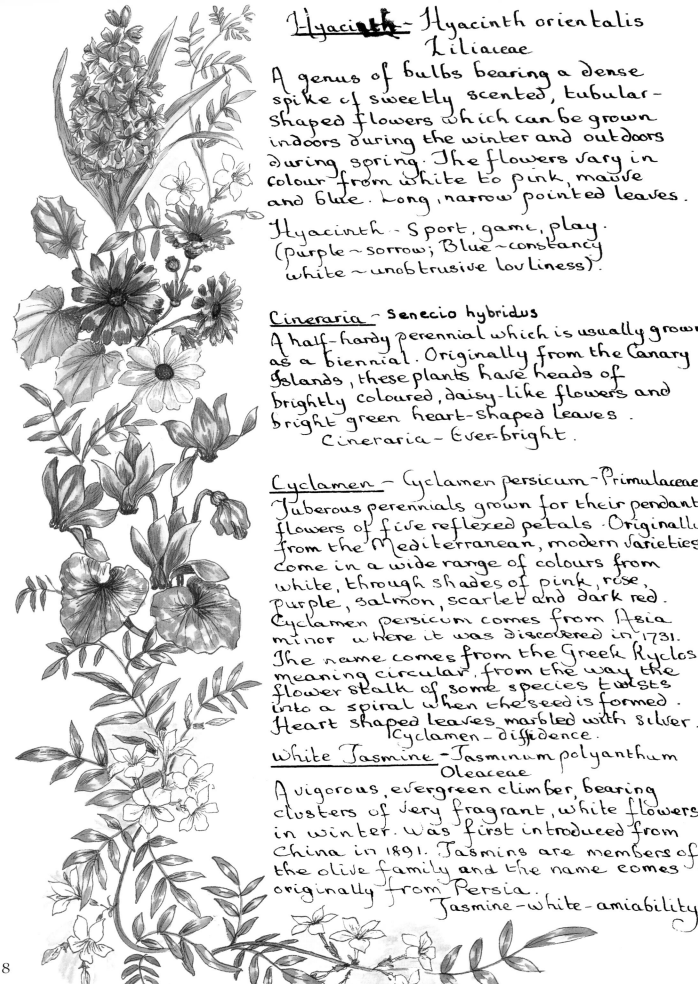

Hyacinth - Hyacinth orientalis
Liliaceae

A genus of bulbs bearing a dense spike of sweetly scented, tubular-shaped flowers which can be grown indoors during the winter and outdoors during spring. The flowers vary in colour from white to pink, mauve and blue. Long, narrow pointed leaves.

Hyacinth - Sport, game, play. (purple ~ sorrow; Blue ~ constancy white ~ unobtrusive lovliness).

Cineraria - Senecio hybridus

A half-hardy perennial which is usually grown as a biennial. Originally from the Canary Islands, these plants have heads of brightly coloured, daisy-like flowers and bright green heart-shaped leaves.
Cineraria - Ever-bright.

Cyclamen - Cyclamen persicum - Primulaceae

Tuberous perennials grown for their pendant flowers of five reflexed petals. Originally from the Mediterranean, modern varieties come in a wide range of colours from white, through shades of pink, rose, purple, salmon, scarlet and dark red. Cyclamen persicum comes from Asia minor where it was discovered in 1731. The name comes from the Greek Kyclos meaning circular, from the way the flower stalk of some species twists into a spiral when the seed is formed. Heart shaped leaves marbled with silver.
Cyclamen - diffidence.

White Jasmine - Jasminum polyanthum
Oleaceae

A vigorous, evergreen climber, bearing clusters of very fragrant, white flowers in winter. Was first introduced from China in 1891. Jasmins are members of the olive family and the name comes originally from Persia.
Jasmine - white - amiability.

18

<u>Windflower</u> - Anemone blanda
Ranunculaceae

Blue - white or pink flowers with
nine to fourteen, narrow petals. The
broadly oval, semi-erect leaves have
three deeply toothed lobes. Grows from
small, spreading, knobbly shaped tubers
Anemone blanda flowers in early spring

<u>Witch Hazel</u> - Hamamelis mollis
Hamamelidaceae

The Chinese Witch Hazel ~ a deciduous,
open, upright shrub which carries loose
petalled, very fragrant, yellow flowers
on bare branches from mid-winter
through to spring. Broadly oval leaves
turn yellow in autumn. The Witch-Hazel
is said to aid the discovery of witches!
Witch-Hazel - A spell.

<u>Coloured Primrose</u> - Primula vulgaris x
Primulaceae

Now available in a wide range of colours
with yellow eye. Bright flowers set
in a rosette of oval to lance shaped
crinkled leaves make brilliant
splashes of colour in a spring border.
Can suffer from bird damage but it is
said this can be controlled if planted
near lavendar.
Primrose - Early youth or sadness.

<u>Lungwort</u> - Pulmonaria officinalis
Boraginaceae

A spring flowering perennial with broadly
oval to lance-shaped leaves spotted with
white. Bell shaped flowers are carried
in clumps at the top of each stem and
can be either pink or blue. The name
'Lungwort' refers to the white blotched
leaves which were said to resemble diseased
lungs and the plant was used to heal
certain lung disorders. Flowers from
March to May.

19

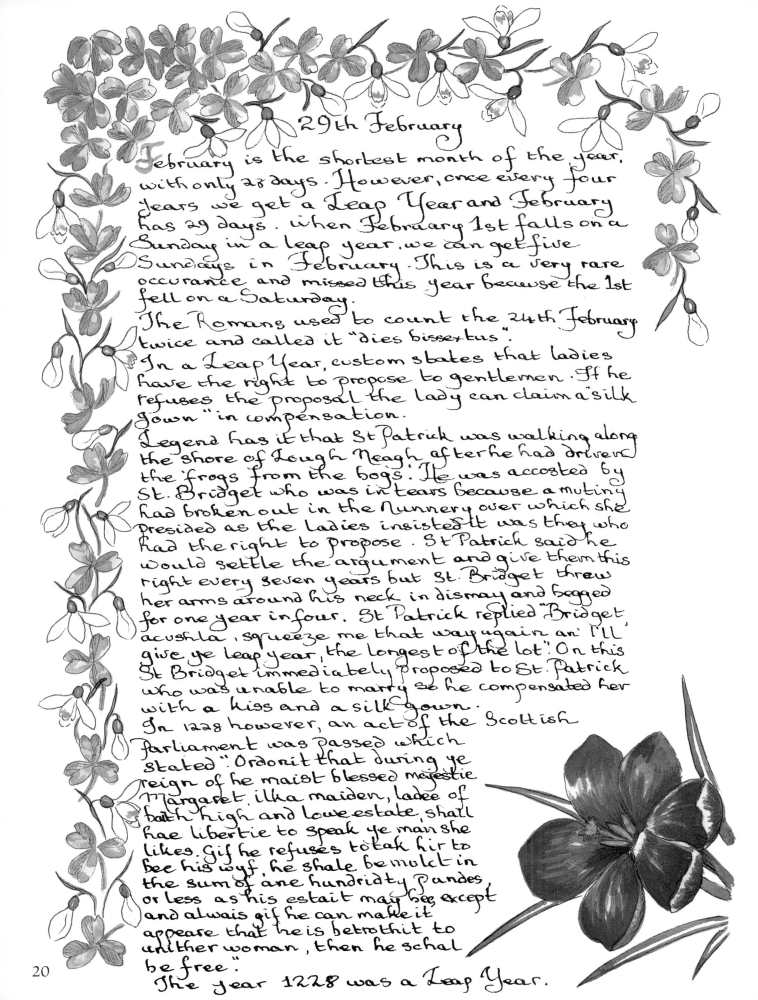

29th February

February is the shortest month of the year, with only 28 days. However, once every four years we get a Leap Year and February has 29 days. When February 1st falls on a Sunday in a leap year, we can get five Sundays in February. This is a very rare occurance and missed this year because the 1st fell on a Saturday.

The Romans used to count the 24th February twice and called it "dies bissextus".

In a Leap Year, custom states that ladies have the right to propose to gentlemen. If he refuses the proposal the lady can claim a silk gown "in compensation.

Legend has it that St Patrick was walking along the shore of Lough Neagh after he had driven the frogs from the bogs. He was accosted by St. Bridget who was in tears because a mutiny had broken out in the Nunnery over which she presided as the ladies insisted it was they who had the right to propose. St Patrick said he would settle the argument and give them this right every seven years but St. Bridget threw her arms around his neck in dismay and begged for one year in four. St Patrick replied "Bridget, acushla, squeeze me that way again an' I'll give ye leap year, the longest of the lot". On this St Bridget immediately proposed to St. Patrick who was unable to marry so he compensated her with a kiss and a silk gown.

In 1228 however, an act of the Scottish Parliament was passed which stated "Ordonit that during ye reign of he maist blessed majestie Margaret, ilka maiden, ladee of baith high and lowe estate, shall hae libertie to speak ye man she likes. Gif he refuses to tak hir to bee his wyf, he shale be mulct in the sum of ane hundridty pundes, or less as his estait may bee, except and alwais gif he can make it appeare that he is betrothit to unither woman, then he schal be free".

The year 1228 was a Leap Year.

I singularly moved
To love the lovely that are not beloved,
Of all the Seasons, most
Love Winter, and to trace
The sense of the Trophonian pallor on her face.
It is not death, but plentitude of peace;
And the dim cloud that does the world enfold
Hath less the characters of dark and cold
Than warmth and light asleep,
And correspondent breathing seems to keep
With the infant harvest, breathing soft below
Its eider coverlet of snow.
Nor is in field or garden anything
But, duly look'd into, contains serene
The substance of things hoped for, in the Spring,
And evidence of Summer not yet seen.
On every chance-mild day
That visits the moist shaw,
The honeysuckle, 'sdaining to be crost
In urgence of sweet life by sleet or frost,
Voids the time's law
With still increase
Of leaflet new, and little, wandering spray;
Often in sheltering brakes,
As one from rest disturb'd in the first hour,
Primrose or violet bewilder'd wakes,
And deems is time to flower;
Though not a whisper of her voice he hear,
The buried bulb does know
The signals of the year
And hails far Summer with his lifted spear.

Coventry Patmore
from "Winter"
Poems, 1894.

Honesty

Oak

Wild clematis

Sycamore

Germander Speedwell
seedling

Scots Pine Cone

Lupin Seed Husks

Sweet Chestnut

Beech

Young Lupin leaves

Moss

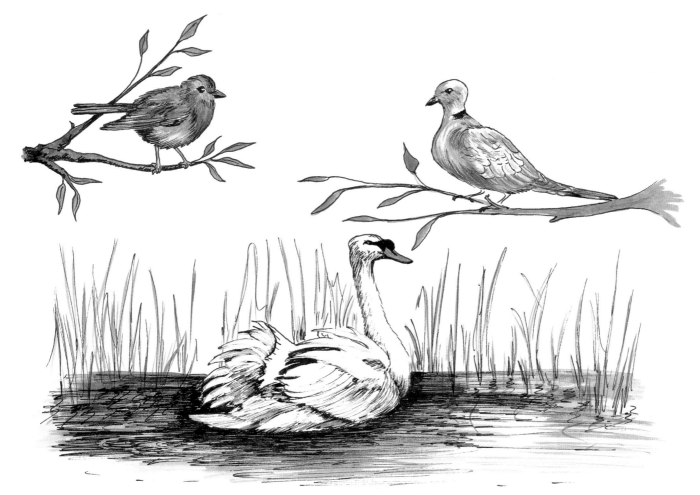

Robin- *Erithaeus rubecula* ~
Small, rather long-legged brown bird
with a striking orange-red breast and face.
Woods, hedges, bushes, gardens.

Collared Dove- *Streptopelia decaocto* ~
Pale, washed out plumage, dull, ash brown
above, light grey brown below. A thin
black, half-collar on hind neck, and in
flight, a white terminal band on underside
of tail and white underwing coverts.
Towns, villages and farms.

Mute Swan- *Cygnus olor* ~
All white, with orange-red bill with
black knob. Wings often partly raised
over back. Breeds on large or small
well vegetated lakes.

Jay ~ *Garrulus glandarius* ~
European birds have pinkish
brown bodies, black and white
crown feathers that can be
raised in crest, white rump,
black tail and mainly black
wing, with blue and white
patches. Woodlands of various
types, with scattered trees,
orchards, gardens, nr. oak trees.

23

In February

The frozen ground is broken
Where snowdrops raise their heads,
And nod their tiny greeting
In glades and garden beds.

The frozen stream is melted,
The white brook turns to brown,
And foaming through the coppice
Flows helter-shelter down.

The frozen air is golden
With February sun
The winter days are over.
Oh ~ has the Spring begun?

~ P. A. Ropes ~

24

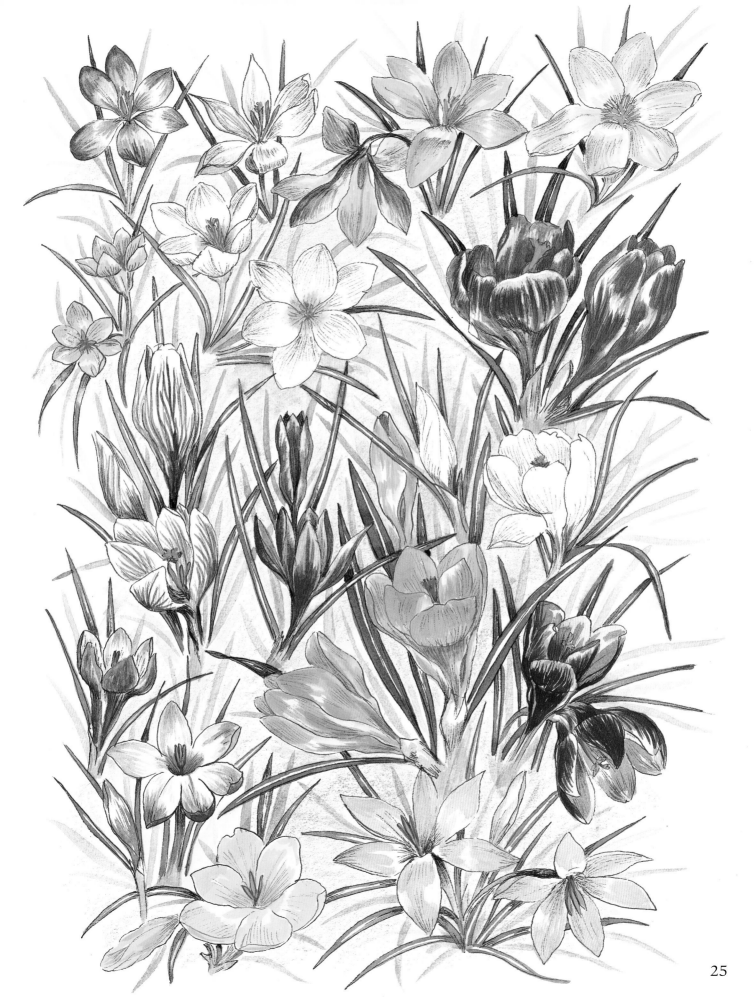

25

March used to be the first month of the year, both in the Roman year and in the English ecclesiastical calendar which was used until 1752. The legal year would commence on the 25th March. In 1599, Scotland changed the first month to January. The month was named after 'Mars', the Roman god of war and they called it 'Martius.' The old Dutch name was Lent-maand (lengthening month) while the Anglo Saxons called it Hreth-monath - rough month, from the strong winds. The name later changed to Hlyd-monath ~ boisterous month.

March

"So many misties in March,
So many frosties in May."

"As mad as a March hare."

"A peck of March dust is worth a King's ransome"

"March'll search ye, April try thee
May'll tell whether live or die ye."

"Though the sun shines, leave not your cloak at home."

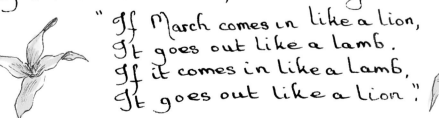

"If March comes in like a lion,
It goes out like a lamb.
If it comes in like a Lamb,
It goes out like a lion."

"A windy March and a rainy April make a beautiful May."

"March winds and April showers
Bring forth May flowers."

"March many weathers"

March usually contains a real mixture of weather, from mild, sunny days, through torrential rain and wild storms and gales with high winds. The first day of Spring falls on the 21st March though it often feels the Spring weather does not really arrive until April or even May!

1st March - St. David's Day

St David is the Patron Saint of Wales and it is customary for Welsh people to wear a leek in their buttonhole on St. David's Day. Some people wear a daffodil as it is said they come into flower on this day. In Lanarkshire March 1st is called "Whoopity Scoorie Day" and bells are rung to chase winter away.

Woke to torrential rain which continued for most of the day, although the sun broke through for a few moments in the late afternoon.

2nd March - St Chad's Day

Chad was Abbot of Lastingham in North Yorkshire and his brother, St Cedd, is buried there. It is said that every goose lays an egg on St. Chad's day!

"Sow peas and beans on Saints
David and Chad
Whether the weather be good or bad".

Cold today but the sun is shining again and there is a beautiful blue sky. The gold-fish are getting very lively in the pool and came up for food with relish. The flowering currant is showing it's first flower. Periwinkle has flowers on and the first Tulipa tarda in flower. One or two daffodils just about to open as well, while the coloured primroses are a mass of blooms in a whole range of colours.

27

Forsythia ~ Forsythia intermedia
Oleaceae

Deciduous, spring flowering shrubs which are covered in a profusion of bright yellow flowers in early spring. The flowers appear on the bare wood and are later followed by sharply toothed, mid-green leaves. Shrubs come mainly from China and Japan. Forsythia —— after W. Forsyth, the English botanist.
Good as a cut flower and will last indoors for a long time if picked when in bud and placed for a few moments first in hot water before arranging.

Daphne - Garland Flower - Daphne mezereum
Thymelaeaceae

Evergreen - semi - evergreen or deciduous shrubs. Small tubular flowers with four spreading lobes which are very sweetly scented. Native to Europe and Asia.
Daphne - ancient name for the bay laurel.

Periwinkle ~ Vinca major
Apocynaceae

An evergreen trailing sub-shrub with broadly oval, glossy, dark green leaves and tubular shaped flowers with five spreading lobes in bright blue. The flowers are produced from Spring to Autumn. Vinca minor has smaller flowers in a softer blue and is more dwarf in habit. Native to Europe and the Mediterranean region.
Vinca …. old Latin name
Periwinkle - Early friendship - blue
Pleasures of memory - white.

Cyclamen - Sowbread - Cyclamen coum
Primulaceae

A winter/spring flowering, hardy, outdoor cyclamen growing from a round, tuberous, flattened corm. Flowers carmine with a darker stain at the mouth. Leaves are heart shaped, silver patterned.
Cyclamen ---- old Greek name, probably from 'Kuklos = a circle, from the shape of the corm

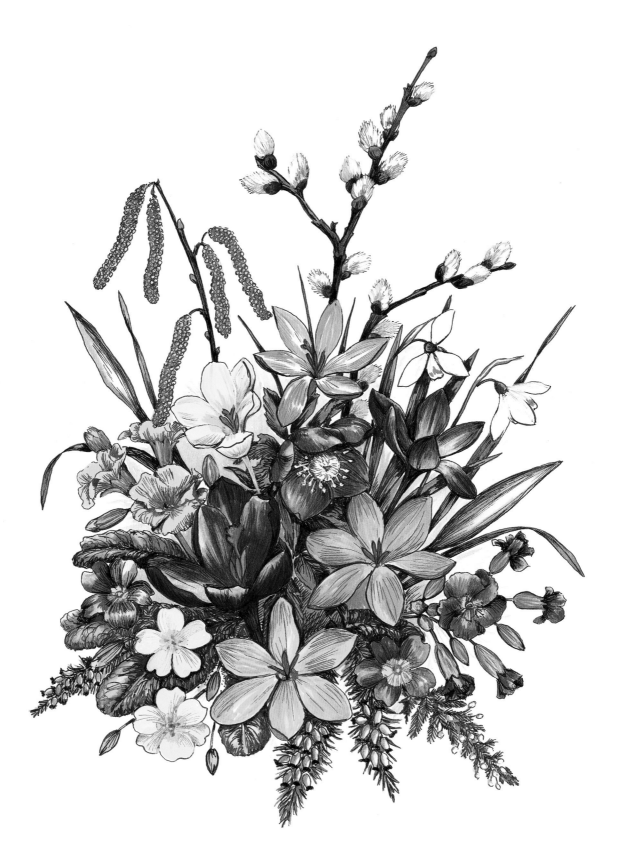

Spring

17th March - St Patrick's Day - Patron Saint of Ireland.

According to Chambers - "We can trace the footsteps of St. Patrick almost from his cradle to his grave by the names of places called after him" Throughout Scotland, England and Ireland we can follow his travels and deeds by the place names. From being born in Dumbartonshire at Kil-patrick (the cell of Patrick) across Scotland to his departure from Port - Patrick. Through England and Wales he departed for the Continent from Ilan - badrig. (Church of Patrick) in Anglesea. He first landed in Ireland at Innis - patrick (Island of Patrick). Sailing northwards, he stopped just above Peel on the Isle of Man at Innis Patrick where he then founded the Church of Kirk Patrick. His travels can be traced back across Ireland where he founded Churches and Abbeys and left a string of place names before dying in Saul on March 17th, 493.

St Patrick's real name was Succat, changed first to Cothraige, then to Magonus and afterwards, (on his ordination) to Patricius.

St Patrick was responsible for clearing the vermin from Ireland, according to tradition. In the end only one old snake resisted. St Patrick made a box and tried to persuade the snake to enter, this however he refused to do, saying the box was too small. In the end, the snake attempted to prove his point by climbing into the box, when St. Patrick immediately closed down the lid and threw the box into the sea. Legend holds that the writhing of the snake forms the waves of the sea and the noise of the sea is made by the snake begging to be released.

To commemorate St. Patrick's Day the Irish wear a sprig of Shamrock.

"The faint fresh flame of the young year flushes

From leaf to flower and flower to fruit."

Algernon Swinburne 1837 - 1909

Among these blushing borders, bright with dew,
And in yon mingled wilderness of flowers,
Fair-handed Spring unbosoms every grace;
Throws out the snowdrop and the crocus first;
The daisy, primrose, violet darkly blue,
And polyanthus of unnumber'd dyes;
The yellow wall-flower, stain'd with iron brown;
And lavish stock that scents the garden round:
From the soft wing of vernal breezes shed,
Anemonies; auriculas, enrich'd
With shining meal o'er all their velvet leaves;
And full ranunculas, of glowing red.
Then comes the tulip-race, where Beauty plays
Her idle freaks; from family diffus'd
To family, as flies the father dust,
The varied colours run; and, while they break
On the charm'd eye, th'exulting florist marks,
With secret pride, the wonders of his hand.
No gradual bloom is wanting; from the bud,
First-born of Spring, to Summer's musky tribes;
Nor hyacinths, of purest virgin white,
Low-bent, and blushing inward; nor jonquilles,
Of potent fragrance; nor narcissus fair,
As o'er the fabled fountain hanging still;
Nor broad carnations, nor gay-spotted pinks;
Nor, shower'd from every bush, the damask rose.
Infinite numbers, delicacies, smells,
With hues on hues expression cannot paint,
The breath of Nature, and her endless bloom.

James Thomson
'The Seasons', 1726-30.

31

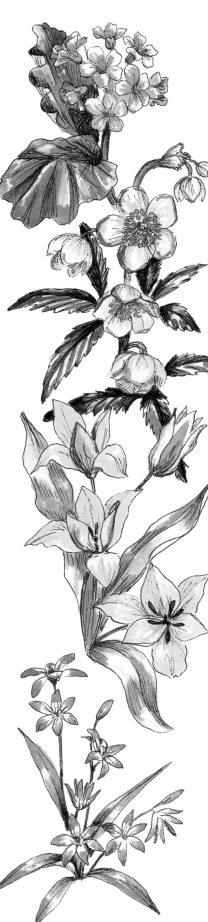

Elephant Leaved Saxifrage - Bergenia Cordifolia
Saxifrageaea

Evergreen. Clump forming perennial growing
up to 24 inches high and having large, oval,
leathery green leaves with crinkled edges,
and good winter colouring. Carries racemes
of open-cup shaped flowers in pale pink
in early spring.

Stinking Hellebore - Helleborus foetidus
Ranunculacea.

Evergreen clump-forming perennial with
deeply divided, dark green leaves with serrated
edges. Carries panicles of drooping, bright-green
flowers bordered with red, from January. Up
to 18 inches high.

Lady Tulip - Tulipa clusiana
Liliaceae

Early spring flowering bulb with narrow,
bright-green, strap-like leaves, bears
small yellow flowers, flushed red and
green on the outside of the petals.
Good for rock gardens.
The tulip known in Persia as the Turban
Plant from thoulyb - thoulyban - a turban.
In the 17 century there was a mania for
collecting tulip bulbs. It reached its height
between 1634-1637 when a root of the species
called Viceroy sold for £250; Semper Augustus
more than double that sum.

Chionodoxa forbessii - Glory of the Snow.

An early spring flowering bulb, height
between 4-10 inches, bearing a loose
spike of deep blue, star shaped
flowers with a white eye. Two
narrow, semi-erect basal leaves
Native to the Mediterranean and the
Near East.

Chionodoxa - Greek Chion.doxa - Snow Glory

Pussy Willow ~ Salix caprea ~ Salicaceae

A genus of deciduous trees and shrubs noted for their silky-grey catkins born in spring. Female catkins are more insignificant than male and most plants bear catkins of only one sex. Catkins followed later with golden pollen giving a very distinctive bright golden splash of colour in woods and hedges. Trees can grow up to 25 foot.

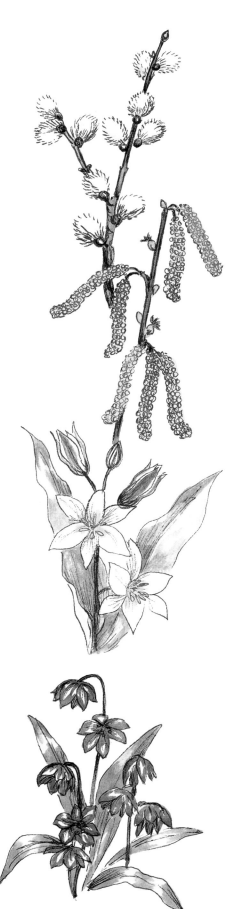

Hazel ~ Corylus avellana ~ Corylaceae

A common, small bushy tree found in open woodland and hedges. Rounded, roughened leaves. The female flowers are dark red and very small and insignificant, surrounded by green bracts. The male flowers are long golden tassels or 'lamb's tails", very conspicuous in early spring when the hedges are bare. In autumn the trees bear small brown nuts enclosed by green bracts. Hazel - reconcilliation.

Tulip ~ Tulip biflora ~ Liliaceae

Flowering in early spring, Tulipa biflora bears stems carrying from 1-5 fragrant flowers, white with yellow centres, the narrow oval petals flushed green-ish-grey on the outside or greenish-pink. Grey-green leaves. Height 2-4 inches, suitable for rock gardens.

Siberian Squill ~ Scilla sibirica ~ Liliaceae

Deep rich blue, bell-shaped flowers born in short spikes in early spring. Bulbs with 2-4 straplike, glossy green basal leaves. Height 4-6 inches. Natives of Europe, Africa and Asia. Flowering March to May.

Scilla - Old Greek name for an onion-like bulb.

33

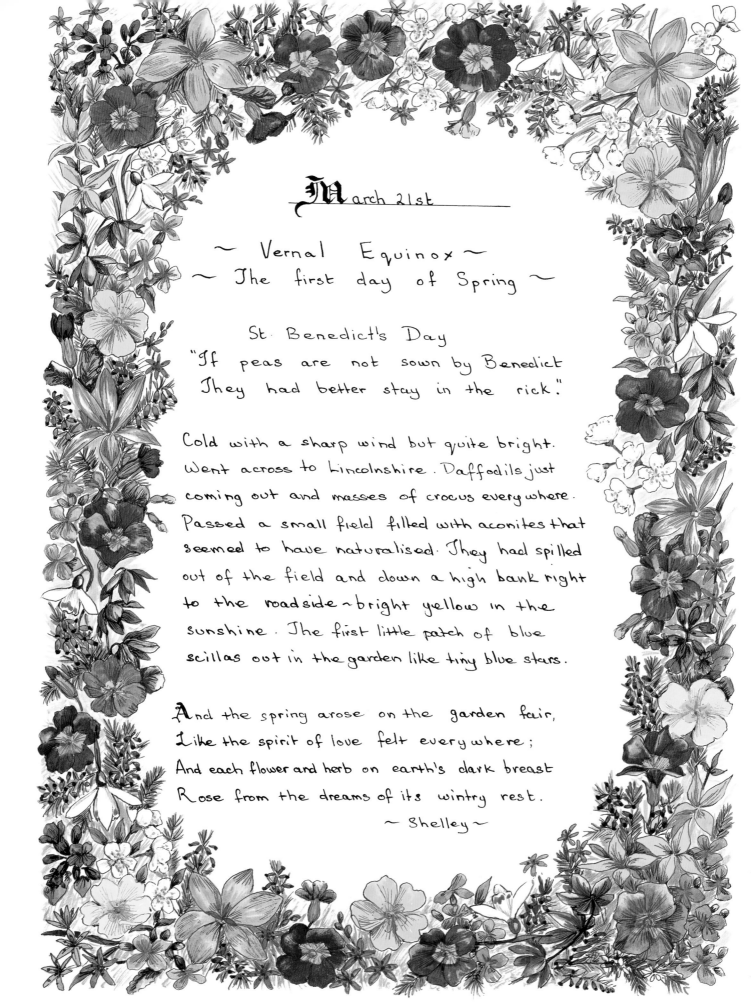

March 21st

~ Vernal Equinox ~
~ The first day of Spring ~

St. Benedict's Day
"If peas are not sown by Benedict
They had better stay in the rick."

Cold with a sharp wind but quite bright.
Went across to Lincolnshire. Daffodils just
coming out and masses of crocus everywhere.
Passed a small field filled with aconites that
seemed to have naturalised. They had spilled
out of the field and down a high bank right
to the roadside ~ bright yellow in the
sunshine. The first little patch of blue
scillas out in the garden like tiny blue stars.

And the spring arose on the garden fair,
Like the spirit of love felt everywhere;
And each flower and herb on earth's dark breast
Rose from the dreams of its wintry rest.
~ Shelley ~

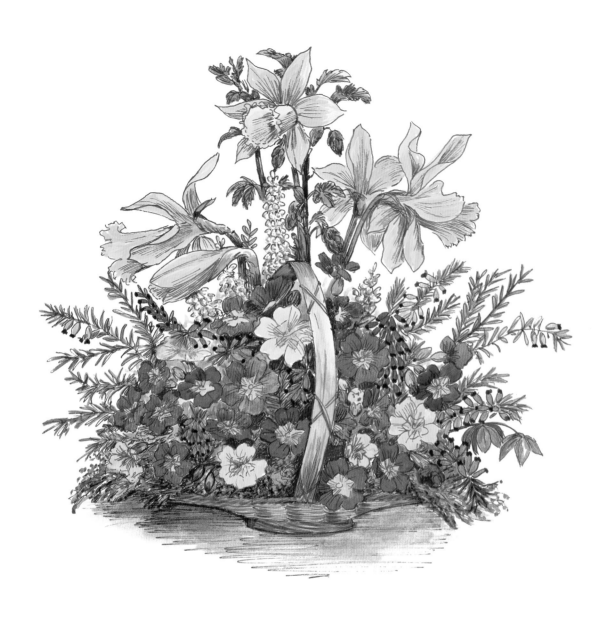

<u>March 29th</u>
Mothering Sunday

The fourth Sunday in Lent, a great holiday celebrated by children
visiting their mothers with gifts. Probably derived from the ancient
custom of visiting "Mother Church" and making offerings on the alter
on that day. The traditional cake was a Simnel cake and sometimes
this day is also known as Simnel Day.

Beautiful sunshine, but very cold and still a strong wind blowing.
There are branches down everywhere in the garden and it is strewn
with debris. The Chionodoxa are coming out underneath the rose
trees and the daisies are just begining to come out on the lawn.

35

The Daffodil or Lent Lily

The daffodil was originally said to
have been white. Persephōne the
daughter of Demetēr loved to wander
through the flower filled meadows of
Sicily. One spring, while down in
the meadows, she put a wreath of
wild lilies in her hair and, being
tired of wandering, lay down in the
grass and fell asleep. Pluto, God of
the Infernal regions fell in love
with Persephōne and carried her
off for his bride. As he touched
her, the white flowers turned to
a golden yellow. Some of the
blooms fell in Acheron where they
grew luxuriantly and ever since,
the flower has been planted on
graves. Theophilus and Pliny tell
us ghosts delighted in the flower
which they called Asphodel and
it was once called the Affodil.

The Year's Awakening

How do you know that the pilgrim track
Along the belting Zodiac
Swept by the sun in his seeming rounds
Is traced by now to the Fishes' bounds
And into the Ram, when weeks of cloud
Have wrapped the sky in a clammy shroud,
And never as yet a tinct of spring
Has shown in the Earth's apparelling;
O vespering bird, how do you know.
 How do you know?

How do you know deep underground,
Hid in your bed from sight and sound,
Without a turn in temperature,
With weather life can scarce endure,
That light has won a fraction's strength,
And day put on some moments' length,
Whereof in merest rote will come,
Weeks hence, mild airs that do not numb;
O crocus root, how do you know,
 How do you know?

 Thomas Hardy
 February 1910.

37

April – The 'opening' month when the trees unfold and the womb of Nature opens with young life – April from the Latin aperi're – to open.

"April weather, rain and sunshine both together."

"Oh, how this spring of love resembleth
The uncertain glory of an April day!
Which now shows all the beauty of the sun
And by and bye a cloud takes all away"
~ Shakespeare ~

April brings the primrose sweet
Scatters daisies at our feet.

"An April flood carries away the frog and his brood"

"My April Morn" ~ my Wedding Day ~ the day when I was made a fool of ~ Brewers ~

"April Gentleman"
A man newly married who has made himself thus "An April Fool"

"When April blows his horn,
Tis good for both hay and corn."

"A cold April the barn will fill"

38

April is notorious for its showers which can be quite torrential! "March winds and April showers bring forth May flowers"! But, aswell as the rain, April also has some beautiful mild days with brilliant blue skies and bright, golden sunshine. It is said the weather in April gives an indication of the weather to come later in the summer.

1st April
All Fools Day

The day when people play tricks and try to make fools of each other. However, the true origin of this custom is not known. It could be that when March 25th was New Years Day, April 1st was its octave, when the festivities culminated. Two other popular explanations are that it refers to the vagaries of the weather or the mockery of the trial of the Redeemer. Perhaps it could also be a relic of the Roman "Cerealia", held at the begining of April. The tale tells that Proserpina was sporting in the Elysian meadows and had just filled her lap with daffodils when Pluto carried her off to the underworld. Her mother, Ceres, heard the echo of her daughter's screams and went in search of 'the voice', but, her search was a fool's errand. It was 'hunting the gowk', or looking for the 'echo of a scream'. This fable is an allegory of seed-time.

In Scotland —'a gowk' (cuckoo). In France — 'un poisson d'Avril' – an 'April Fish'.

'The first of April some do say
Is set apart for All Fools Day
But why the people call it so
Nor I, nor they themselves do know'.

Traditionally jokes can only be played up until mid-day ~ Anyone playing a joke after that time, becomes the fool themselves.

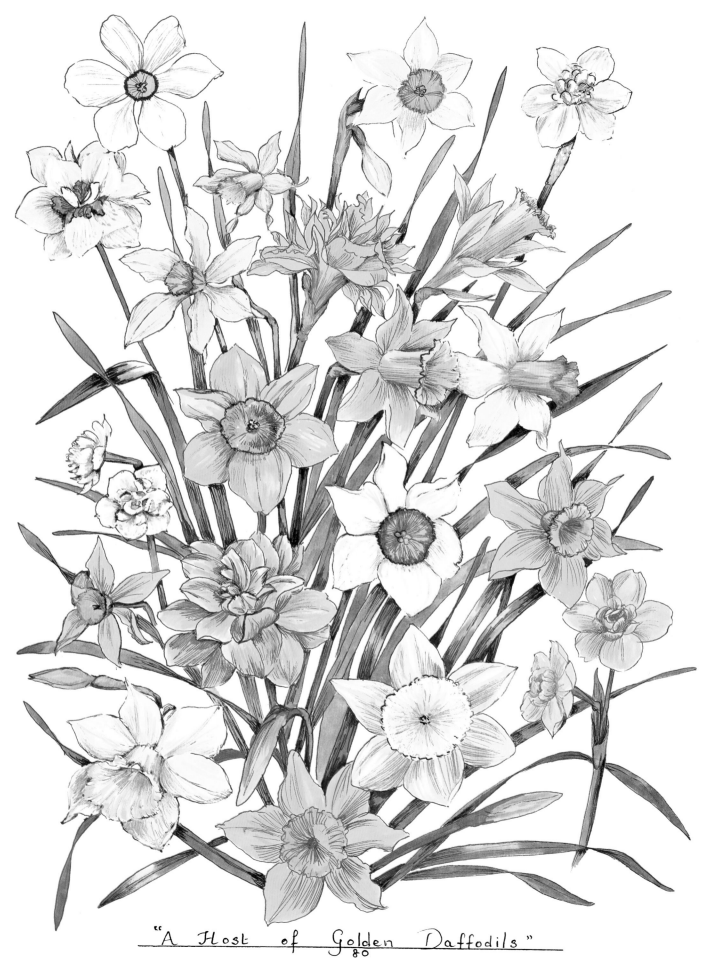

"A Host of Golden Daffodils"

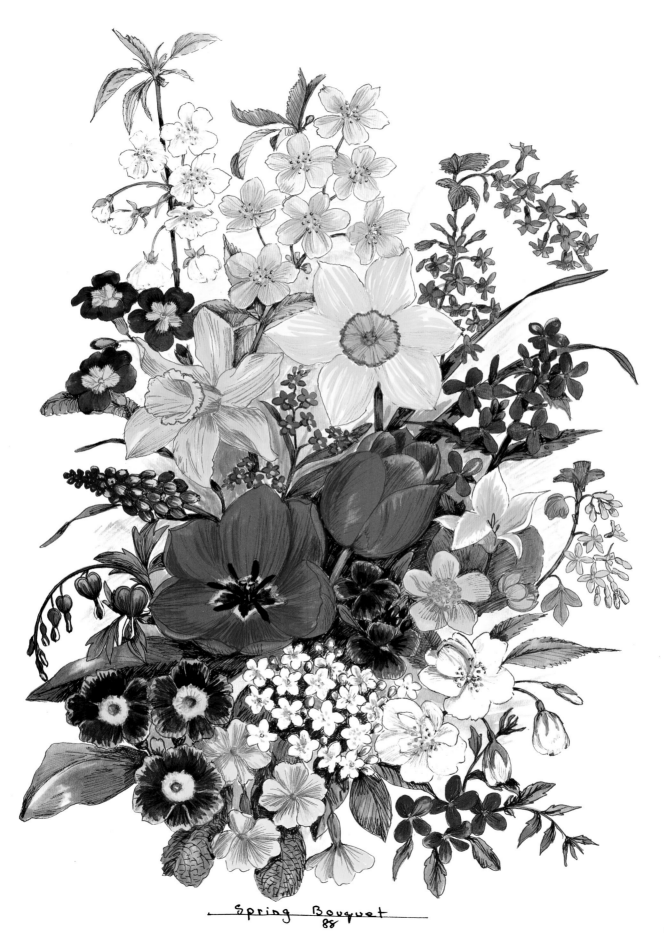

Spring Bouquet
88

41

Young Beech Leaves

16th April ~ Maundy Thursday

Sometimes called Holy Thursday, the name Maundy coming from "Mandatum novum do vobis" - "A new Commandment I give unto you" from the wording of the Roman Catholic Latin Mass for the day. During the Mass, the Priest performed a ceremonial washing of the congregations' feet in commemoration of Christ washing the feet of the disciples. Until 1689, the Sovereign washed the feet of the poor in Westminster Abbey. But, since the time of James II, the custom has been to give money to the poor. The money is specially minted and called 'Maundy' money and is given to a number of pensioners to correspond with the Sovereign's age. Until 1953, when Westminster Abbey was being prepared for the Coronation of Queen Elizabeth II, the ceremony had always been performed there, in this year it was moved to St Paul's Cathedral and since then, the ceremony has been held in different Cathedrals around the country.

Maundy is also said to have derived its name (Spelman) from 'maund' - a basket. On the day before the great feast good Catholics and Religious institutions brought out food in 'maunds' to distribute amongst the poor. In many places this custom gave rise to fairs.

17th April ~ Good Friday ~

"One a penny, two a penny, Hot Cross Buns'!
Spicey buns, the tops marked with a cross, were traditionally made and served on Good Friday. Now they are in the shops well in advance of the day, but it is said that if they are actually made on Good Friday, the symbol of the cross on the buns would protect the house from fire during the coming year. It is also said that the buns made on this day will never go bad, however long they are kept. Good Friday is the anniversary of the Crucifixion, the 'good' meaning 'holy'. Superstition states that those born on Good Friday (and Christmas Day) have the power to see and command the spirits. Good Friday is the day for planting potatoes and also Parsley

Home Thoughts From Abroad

O to be in England
Now that April's there,
And whoever wakes in England
Sees some morning, unaware.
That the lowest boughs and the brushwood sheath
Round the elm-tree bole are in tiny leaf,
While the chaffinch sings on the orchard bough
In England — now!

And after April when May follows
And the whitethroat builds, and all the swallows!
Hark, where my blossom'd pear-tree in the hedge
Leans to the field and scatters on the clover
Blossoms and dew-drops — at the bent spray's edge —
That's the wise Thrush: He sings each song twice over,
Lest you should think he never could recapture
The first fine careless rapture!
And though the fields look rough with hoary dew,
All will be gay when noon-tide wakes anew
The buttercups, the little children's dower
~ Far brighter than this gaudy melon-Flower!

Robert Browning.

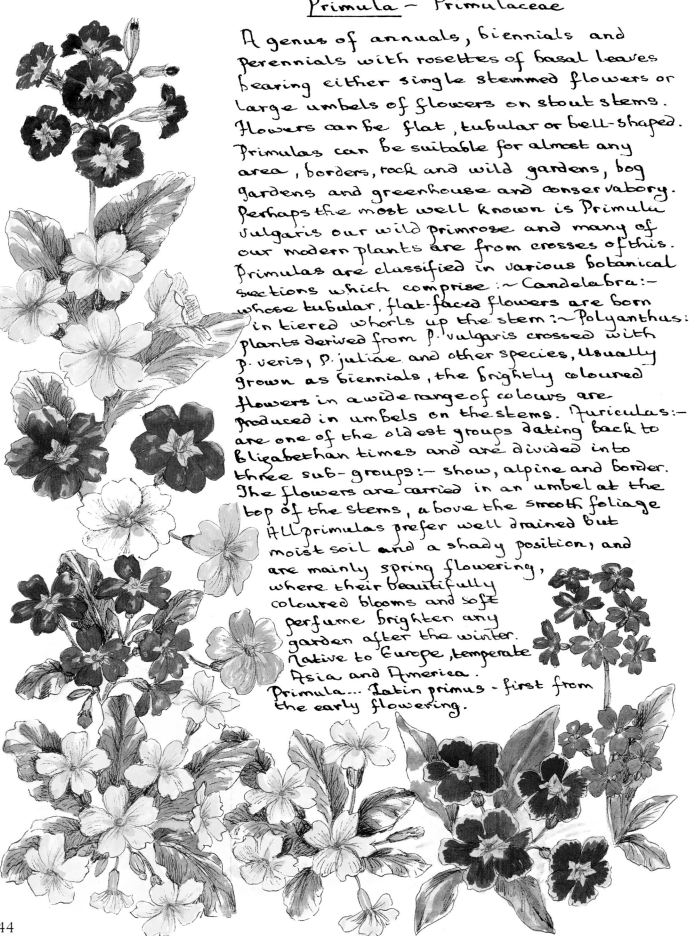

Primula ~ Primulaceae

A genus of annuals, biennials and perennials with rosettes of basal leaves bearing either single stemmed flowers or large umbels of flowers on stout stems. Flowers can be flat, tubular or bell-shaped. Primulas can be suitable for almost any area, borders, rock and wild gardens, bog gardens and greenhouse and conservatory. Perhaps the most well known is Primula vulgaris our wild primrose and many of our modern plants are from crosses of this. Primulas are classified in various botanical sections which comprise :~ Candelabra:~ whose tubular, flat-faced flowers are born in tiered whorls up the stem :~ Polyanthus: plants derived from P. vulgaris crossed with P. veris, P. juliae and other species, Usually grown as biennials, the brightly coloured flowers in a wide range of colours are produced in umbels on the stems. Auriculas:~ are one of the oldest groups dating back to Elizabethan times and are divided into three sub-groups:~ show, alpine and border. The flowers are carried in an umbel at the top of the stems, above the smooth foliage All primulas prefer well drained but moist soil and a shady position, and are mainly spring flowering, where their beautifully coloured blooms and soft perfume brighten any garden after the winter. Native to Europe, temperate Asia and America.
Primula.... Latin primus - first from the early flowering.

Spring

When daisies pied and violets blue,
And lady-smocks all silver white,
And cuckoo buds of yellow hue
Do paint the meadows with delight,
The cuckoo then on every tree,
Mocks married men; for thus sings he,
 Cuckoo!
Cuckoo, cuckoo! – O word of fear,
Unpleasing to a married ear!

When shepherd's pipe on oaten straws,
And merry larks are ploughman's clocks,
When turtles tread, and rooks, and 'daws,
And maidens bleach their summer smocks
The cuckoo then, on every tree,
Mocks married men; for thus sings he
 Cuckoo!

Cuckoo, cuckoo! – O word of fear,
Unpleasing to a married ear!

 William Shakespeare
 1564 – 1616.

45

Easter Day

19th April

April was called 'Ostermonath' or the month of the Ost-end wind (wind from the east). Easter is the April feast which lasted for eight days. Easter day is regulated by the paschal moon, or the first full moon between the vernal equinox and the following fourteen days. Easter Sunday must fall between March 21st. and April 25th, and celebrates the end of the Lenten feast when meat and sweets could be eaten again. Easter eggs are traditionally eaten at this time. Eggs can be hard boiled and decorated or made of chocolate or sugar. "Pace Eggs", 'Paste Eggs or Pasche Eggs are symbolical of creation or the re-creation of Spring. The custom is Magian or Persian in origin but also known amongst the Jews, Egyptians and Hebrews. The custom was adapted by Christians to symbolise the resurrection. Eggs coloured red as an allusion to the blood of their redemption. In some areas of the country Pace Egg plays were performed with Morris dancing in return for sweets or money ~ Easter Eggs were rolled possibly as a link to the stone rolling away from Christ's tomb. The breaking of the shells could be linked with the heathen idea of eggs opening, bringing forth new life. and there is also a tradition that the world was created or 'hatched' at Easter time. At one time it was believed that the sun danced on Easter Day.

"But oh she dances such a way.
No sun upon an Easter Day
is half so fine a sight".
Sir John Suckling.

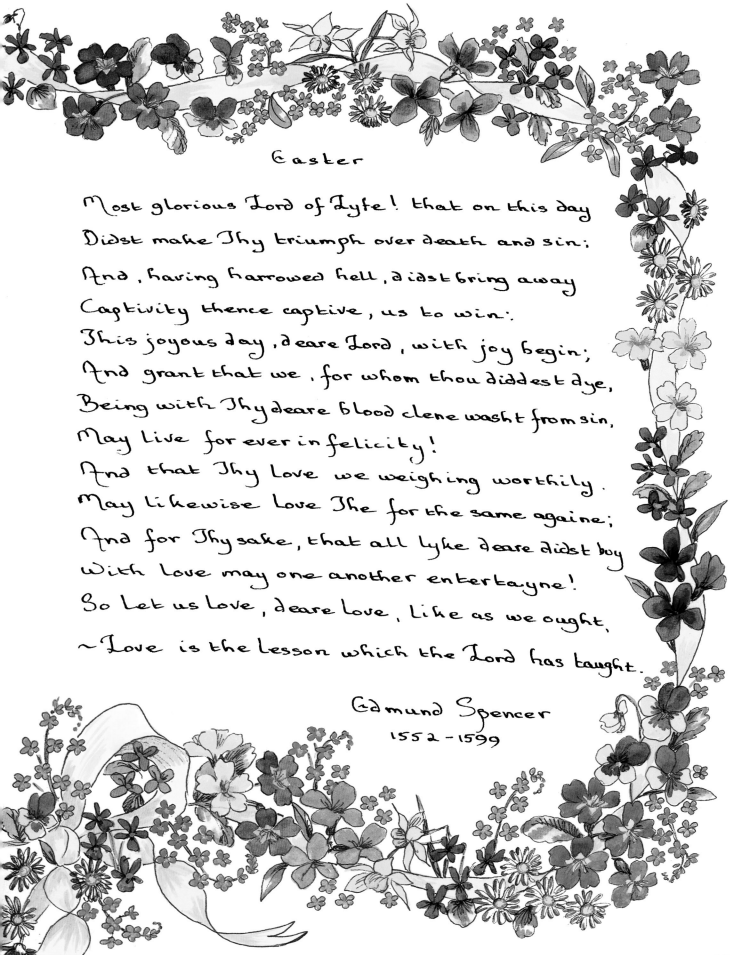

Easter

Most glorious Lord of Lyfe! that on this day
Didst make Thy triumph over death and sin;
And, having harrowed hell, didst bring away
Captivity thence captive, us to win:
This joyous day, deare Lord, with joy begin;
And grant that we, for whom thou diddest dye,
Being with Thy deare blood clene washt from sin,
May live for ever in felicity!
And that Thy love we weighing worthily.
May likewise love The for the same againe;
And for Thy sake, that all lyke deare didst boy
With love may one another entertayne!
So let us love, deare love, like as we ought,
~Love is the lesson which the Lord has taught.

Edmund Spencer
1552 - 1599

47

Columbine - Grannies bonnets -
 Aquilegia vulgaris ~ Ranunculaceae
Delicate, clump forming perennials
with bell-shaped spurred flowers
in a wide range of colours born in
spring and early summer. Fern-
like foliage
Columbine ~ Folly; purple ~Resolution;
Red, Anxious and trembling.

Lily of the Valley ~ Convallaria majalis.
 Liliaceae
Spring-flowering plants growing from
rhizomes. Prefers semi-shade.
Carries sprays of small, white, bell-
shaped flowers which are very fragrant
Most plants bear two, occasionally
three broadly oval leaves. The fruit
is a red berry and all parts of the
plant are poisonous. Grows wild
locally in England, Wales and Scotland
but becoming rarer. Flowers May to
June.
Convallaria --- Latin con-vallis =
associated with valleys.

Lily of the Valley ~ return of happiness.

Bugle - Ajuga reptans
 Labiatae
Herbaceous plants with creeping root-stocks
Flowers arranged in tiers, crowded into a
spike ~ mainly blue but can also be pink
of white. Common on damp ground
flowering from April to July.
Ajuga — from the Latin a-jugum —
without yoke, from the calyx.
Thrift- Sea Pink - Armeria maritima
 Plumbaginaceae
Evergreen perennials with tufts of narrow
green leaves. Stems bearing round heads
of many small pink to white flowers in
summer.

48

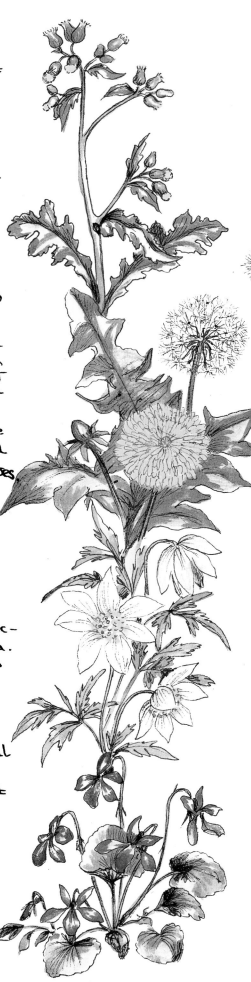

Groundsel ~ Senecio vulgaris
Compositae

The common groundsel is an abundant plant of cultivated ground. It flowers throughout the year and bears loose heads of insignificant green/yellow flowers. Lance shaped, divided leaves and fluffy white seed-heads.

Dandelion - Taraxacum officinale
Compositae

A perennial herb with a long tap root and a basal rosette of oblong, toothed leaves. Flowers yellow, followed by a white, fluffy, globular seed-head "dandelion clock". A native of Europe, the dandelion is a common weed of gardens and grassland. Dandelion from the French - 'dent de lion' = Lion's tooth from the medieval Latin name 'dens leonis'. Jagged leaves.

Dandelion - oracle

Wood Anemone - Windflower -
Anemone nemerosa - Ranunculaceae

Forms carpets of white flowers in woodland in spring. Nodding white cup-shaped flowers — occasionally lilac - var. purpurea or pale blue - var. caerula. Dislikes acid soil. Flowers March to May.

Sweet Violet ~ Viola odorata
Violaceae

A semi-evergreen, rhizomatous perennial with toothed, heart-shaped leaves and short stemmed flat-faced pale violet coloured flowers in spring. Flowers have a sweet perfume — Can also be white flowered. Self-seeds prolifically.

Viola - classical name.

Sweet violet - modesty.

49

Cherry - Prunus
Rosaceae

A genus of evergreen or deciduous trees and shrubs, grown for their beautiful single or double flowers which are produced mainly from early to late Spring. All species have oval to oblong leaves. Most varieties of Cherry originated in China or Japan where single flowered varieties have been recorded over a thousand years ago. It is thought that 'yamazakura' or the 'hill' or 'mountain' Cherry reached Japan from China in the sixth or seventh century and is said to have been planted by En-no-ozunu, a Buddhist priest. This ancient form of the Cherry has always been the favourite amongst the Japanese and has given inspiration to their artists and poets. The pure white blossom is an emblem of chivalry and knightly honour as well as purity. The autumn Cherry - Prunus subhirtella 'Autumnalis' is recorded in a Japanese legend which dates back to 408 A.D, although it was only introduced into England about 1900. Cherries were brought into England from the early 1800's and now there is a wide range of trees from white flowered singles and doubles to deepest pink.

Loveliest of trees, the cherry now
Is hung with bloom along the bough
. . . .
About the woodland I will go
To see the cherry hung with snow.

A. E. Houseman.

50

Marsh Marigold - King-cup - Caltha palustris
Ranunculaceae

Bright, golden yellow flowers and oval, glossy green leaves can be seen on marshy ground or at the margins of pools in spring. Fully hardy, deciduous perennials which require moist ground and full sun.

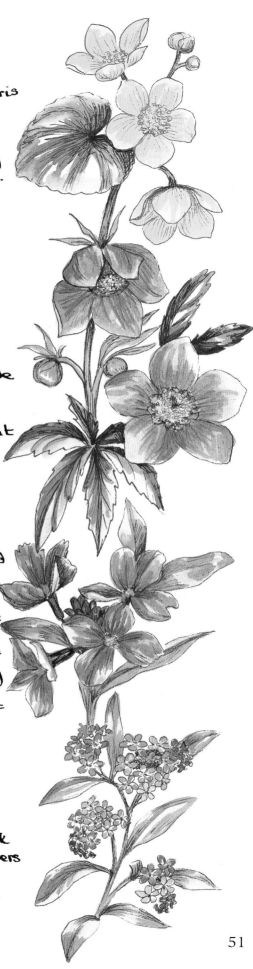

Lenten Rose - Helleborus orientalis
Ranunculaceae

Flowering in spring, the Lenten rose has open to cup-shaped purple flowers with a central boss of yellow stamens. Dark green, palmate leaves. Prefers semi-shade and grows well in woodland or woodland margins.

Helleborus - old Greek name for this plant and also the Christmas rose.

Hellebore - Scandal, calumny

Wallflower - Gillyflower ~ Cheiranthus
Cruciferae

Evergreen or semi-evergreen perennials and sub-shrubs with woody stems and narrow, lance-shaped leaves. The four-petalled flowers come in a wide range of colours and are heavily perfumed, flowering from spring to early summer. Plants grow to about 18" with a dwarf variety growing from 6" - 9".

Cheiranthus - from the Greek 'cheir-anthos' = handflower - i.e. posy.

Wallflower. Fidelity in adversity.

Forget-me-not ~ Myosotis.
Boraginaceae

Perennials or biennials native to temperate regions, mainly Europe and Australia.

Flowers from March to May with blue, pink or white, five petalled, flat, spreading flowers which overlap from the right.

Myosotis - Greek mus-otos = mouse ear from the soft leaves.

Forget-me-not - True love.

51

Although some say May is named after Maia, the mother of Mercury, to whom Roman sacrifices were made on the first day of this month, the word existed long before either Mercury or Maia had been introduced. Another source could be from the Roman 'majores', senators to whom the month was dedicated or from the Latin Maius – i.e. 'Magius' from the root 'mag', the same as the Sanscrit 'mah' – to grow; It means the growing or shooting month. The Anglo-Saxons called it Trimilce as the cows were milked three times each day. May is the fifth month of the year but the third of the old Roman Calendar. The Romans called it the month of Mary.

May

"Don't cast a clout
Till May is out."

"A cold May and a windy
A full barn will find ye."

"May brings flocks of little lambs
Skipping by their fleecy dams."

"Who doffs his coat on a winter's day
Will gladly put it on in May."

"March winds and April showers
Bring forth May flowers."

"A wet May brings a good load of hay."

"swarm of bees in May is worth a load of hay."

"Rain in May makes bread the whole year."

"Sheer your sheep in May
and sheer them all away."

"Be it weal or be it woe
Beans blow before May doth go."

"A hot May, makes for a full Churchyard."
'The Queen of the May'
The girl chosen to be Queen of the games on May Day.
'May bloom' – Hawthorn blossom

'May Lily' – Lily of the Valley.

52

1st May
May Day

The feast of Saints Philip and James the Lesser. The 1st of May is one of the great rural festivals though not upheld now to the extent it was some years ago. In some places, the holiday, now celebrated on the Monday nearest to the 1st of May, is still marked by Maypole dancing — the 'Maypole' painted and decked with flowers and ribbons which are twined into patterns as the dancers move round. In some areas an old superstition sayes that washing in the dew at sunrise was a guarantee of a good complexion and beauty. A May Queen was chosen from the prettiest girls in the village and the May King or 'Jack in the green' was dressed in oak and hawthorn leaves and danced with the May Queen. An old Roman superstition said May was unlucky for weddings ~ Ovid sayes "The common people profess it is unlucky to marry in the month of May". In this month were the festivals of Bona Dea, the Goddess of Chastity and the feast of the dead called Lemuralia.

The month of May shows foliage, flowers and birdsong at their best although it is a month of variable weather ~ temperatures can be very high or very low and the same can apply to the rainfall. However, traditionally a cold May is said to be better for both the harvest and the people.

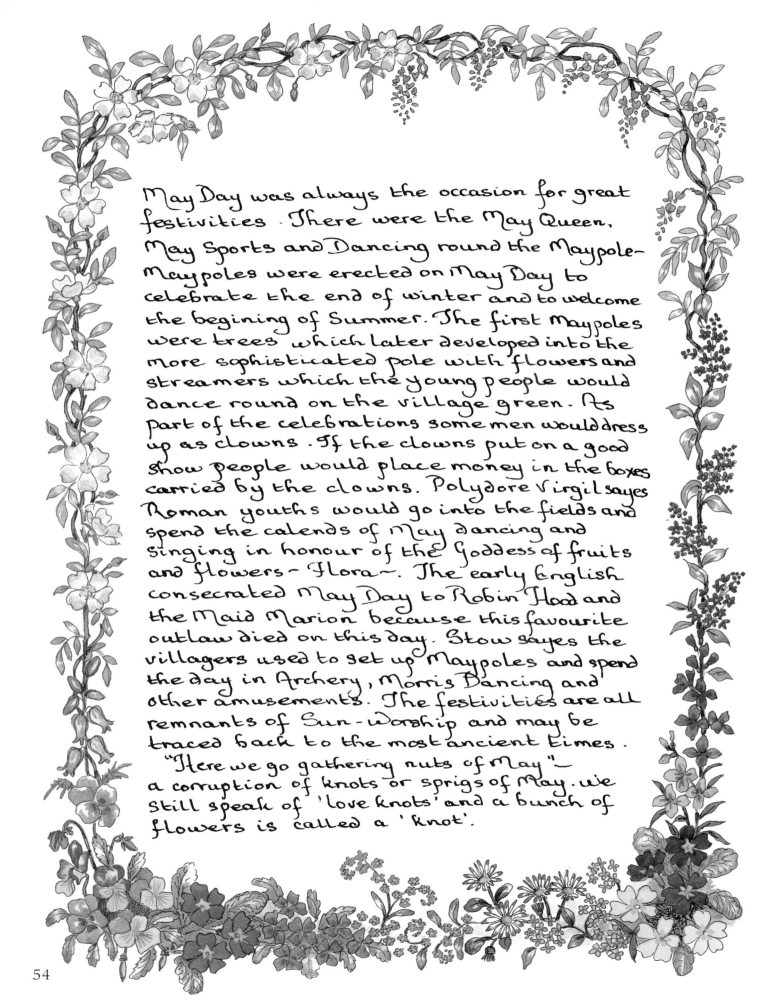

May Day was always the occasion for great festivities. There were the May Queen, May Sports and Dancing round the Maypole—Maypoles were erected on May Day to celebrate the end of winter and to welcome the begining of Summer. The first Maypoles were trees which later developed into the more sophisticated pole with flowers and streamers which the young people would dance round on the village green. As part of the celebrations some men would dress up as clowns. If the clowns put on a good show people would place money in the boxes carried by the clowns. Polydore Virgil sayes Roman youths would go into the fields and spend the calends of May dancing and singing in honour of the Goddess of fruits and flowers — Flora —. The early English consecrated May Day to Robin Hood and the Maid Marion because this favourite outlaw died on this day. Stow sayes the villagers used to set up Maypoles and spend the day in Archery, Morris Dancing and other amusements. The festivities are all remnants of Sun-Worship and may be traced back to the most ancient times.

"Here we go gathering nuts of May"— a corruption of knots or sprigs of May. We still speak of 'love knots' and a bunch of flowers is called a 'knot'.

1st May

Not too warm but at least the sun is shining. The first rosebud has opened on the Zephyrin rose.

5th May

Having struggled to give a small Gardenia plant the humidity it needs indoors, have been rewarded with a beautiful, heavily scented, pure white flower.

6th May

After a few cold days with a chill breeze, the weather has turned mild again and we have been able to sit out in the garden. The warmth seems to have woken everything up ~ A Queen wasp has been hunting along the bank under the hedge, looking for a hole to start a nest, a peacock butterfly has been doing the rounds of the flowers while two blue butterflies have been fluttering in and out of the rose on the fence. The garden is a haze of blue with forget-me-nots and bluebells and the wallflowers are filling the air with perfume. The wysteria buds are showing and the birds are kept busy carrying food for their young.

7th May

There is a wonderful display of gorse and dandelions this year – verges and banks one vivid splash of yellow. Woods full of bluebells below the pale green of the opening trees, soft green of new beech leaves and a magnificent copper beech just coming into leaf with pink tinted leaves. More butterflies around today ~ Orange tip ~ Large white, Small Tortoishell and Grayling.

55

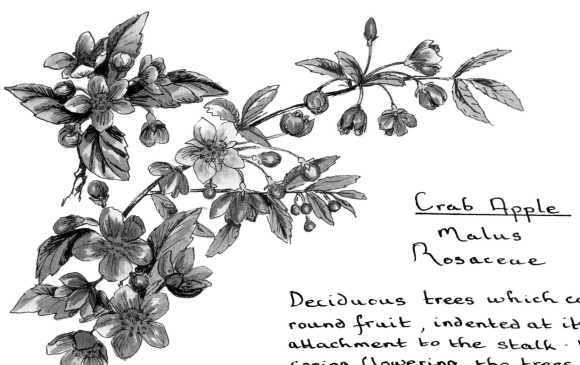

Crab Apple
Malus
Rosaceae

Deciduous trees which carry a round fruit, indented at its attachment to the stalk. Mainly spring flowering, the trees and shrubs are grown for their small, cup-shaped flowers in shades of white, pink and red ~ the attractive spring and autumn colouring of the leaves and the small fruits or crab-apples, which make a delicious preserve and can be vividly coloured.

Crab Apple Jelly
6 lb crab apples
3 pints water
2 lb sugar and
Juice of half a lemon to each quart of juice

Roughly cut up the apples and place in preserving pan with the water. Bring to the boil and boil gently until the apples are soft and the juice is all drawn. Strain through a scalded jelly bag overnight. Do not touch or squeeze the bag or the jelly will become cloudy. Measure the juice into a clean pan and add sugar and lemon. Stir over low heat until sugar is completely dissolved then boil rapidly until setting point is reached. Bottle in clean, warmed jars, decorated with an attractive label and ribbon bow.

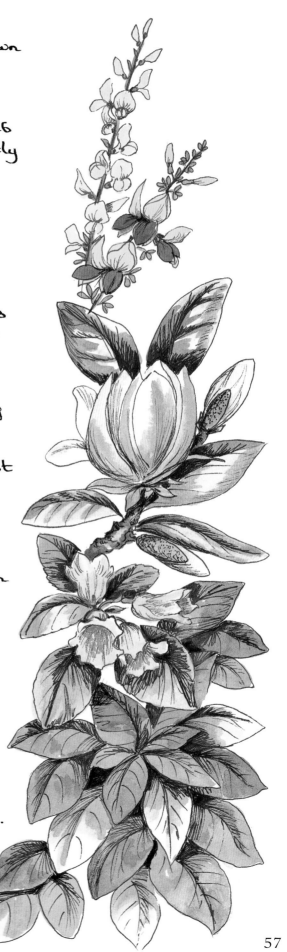

Broom - Cytisus - Leguminosae
Shrubby plants with green branches grown
for their profuse, pea-like flowers in
white, cream, pinks, yellow and bi-
colours with red. Leaves frequently
with three leaflets. A sun loving shrub
flowering April/May. Some with sweetly
scented flowers.
Broom - Neatness - Humility

Magnolia - Magnoliaceae
Trees and shrubs with scattered simple
leaves. The leaf and flower buds are
enclosed by sheathing stipules which
can be downy. Flowers are conspicuous
and solitary, opening wide from a deep
cup shape, generally white but some
species flushed pink or mauve,
occasionally pink or yellow flowers.
Many species in cultivation varying
in size from 1" across to several inches
in diameter. Some are fragrant.
Called magnolia after a French botanist
Pierre Magnol.
Magnolia - Dignity

Weigela - Weigela middendorffiana
 Caprifoliaceae
A genus of deciduous shrubs grown
for their attractive, funnel-shaped
flowers, sulpher-yellow in colour,
spotted with orange inside, borne
midst bright green foliage on an
arching shrub.

Actinidia kolomikta
 Actinidiaceae
A deciduous woody-stemmed, twining
climber, the leaves having creamy-
white or pink coloured upper sections.
Small cup-shaped white flowers in
summer.

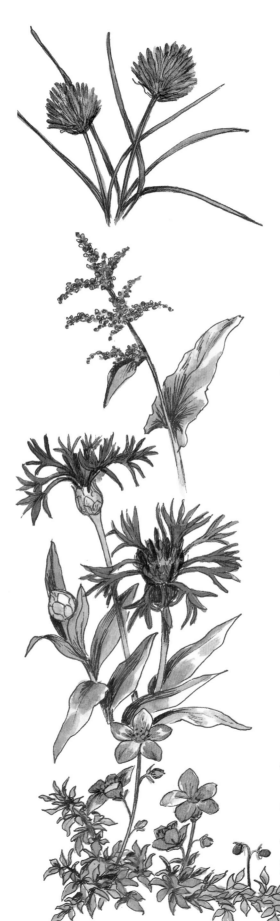

Chives - Allium schoenoprasum
Liliaceae

A widespread perennial plant which grows up to about twelve inches in height. Small, elongated bulbous roots with hollow cylindrical leaves used for flavouring because of their onion-like taste. Stems bear a terminal cluster of purple flowers in late spring.

French sorrel - Rumex acetosa
Polygonaceae

A perennial plant which prefers damp ground. The stem grows up to three feet in height with alternate oblong-oval leaves with two pointed lobes at the base. Flowers from May to August in panicled racemes which are green or reddish in colour. Used as a culinery herb.

Sorrel - Affection

Perennial Cornflower ~ Centaurea montana
Compositae

The perennial Cornflower or knapweed bears lax stems with large deep blue flower heads with thistle like centres surrounded by star-shaped ray petals. Flowers can also be pink or white. Grey green narrowly pointed leaves. Flowers May to June.

Centaury ~ Felicity

Mossy Saxifrage ~ Saxifrage
Saxifragaceae

Spreading mossy clumps which can form quite large plants. Finely divided leaves and delicate flower stems bearing branched heads of one or two flowers in colours from white to dark red. Good for rock gardens or the edges of paths.

<u>Wisteria</u> ~ Wisteria sinensis
 Leguminosae
Woody stemmed, deciduous climbing
plants which climb by twisting and
twining the shoots and stems around the
support. Can grow very high and lush.
Leaves made up of oval leaflets. The
flowers, carried in long racemes are
pea-shaped and lilac coloured. Also
white and double varieties.

 Wisteria ~ I cling to thee

<u>Golden Chain - Golden Rain ~ Laburnum</u>
Laburnum anagyroides. Leguminosae.
Deciduous trees covered profusely in
spring with long racemes of bright golden
pea-shaped flowers. Grey-green leaves
have three oval leaflets. Seeds are
very poisonous.

Laburnum ~ forsaken - pensive beauty.
<u>False Acacia</u> ~ <u>Locust Tree</u>
Robinia pseudoacacia ~ Leguminosae
A native plant of North America, the tree
was introduced to France in the 17th Century
and is now a popular ornamental tree.
Brown bark, later grey, furrowed and twisted.
Alternate leaves, grey-green with seven
to fifteen stalked, oval, entire leaflets.
Pendulous racemes of fragrant white
flowers from the leaf axils on young shoots
Parts of the plant are poisonous - i-e;
seeds, roots and bark. 'Robinia in honour
of Jean Robin, the French botanist who
collected the seeds from America and grew
them in Paris at the Jardin des Plantes.
<u>May - Hawthorn</u> ~ Crataegus **monogyna**
 Rosaceae
A deciduous, spreading tree up to 20 feet
high. Lobed and toothed, glossy-green
leaves on spiny branches. Five petalled
white flowers appear in clusters in
early summer, followed by conspicuous
red fruits loved by the birds. Widely
distributed throughout Europe and the
British Isles, growing in hedges, scrub
and woodland. There are various
cultivated varieties which are usually
double and pink forms.

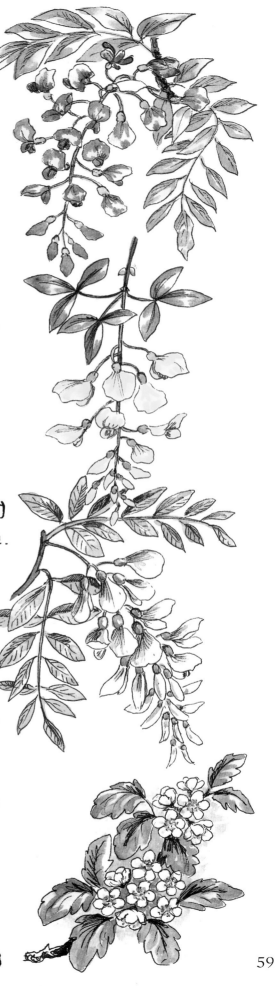

Orchards

Sometimes in Apple country you may see
A ghostly orchard standing all in white,
Aisles of white trees, white branches, in the green,
On some still day when the year hangs between
Winter and spring, and heaven is full of light.
And rising from the ground pale clouds of smoke
Float through the trees and hang upon the air,
Trailing their wisps of blue like a swelled cloak
From the round cheeks of breezes. But though fair
To him who leans upon the gate to stare
And muse "How delicate in spring they be,
That mobled blossom and that wimpled tree",
There is a purpose in the cloudy aisles
That took no thought of beauty for its care.
For here's the beauty of all country miles,
Their rolling pattern and their space:
That there's a reason for each changing square,
Here sleeping fallow, there a meadow mown,
All to their use ranged different each year,
The shaven grass, the gold, the brindled roan,
Not in some search for empty grace,
But fine through service and intent sincere

<div align="right">Victoria Sackville-West.</div>

Wood Pictures in Spring

The rich brown umber hue the oaks unfold
When springs young sunshine bathes their trunks
in gold
So rich so beautiful so past the power
Of words to paint — my heart aches for the
dower
The pencil gives to soften and infuse
This brown luxuriance of unfolding hues
This living luscious tinting woodland give
Into a landscape that might breath and live
And this old gate that claps against the tree
The entrance of springs paradise should be
Yet paints itself with living nature fails
—The sunshine threading through these
broken rails
In mellow shades — no pencil eer conveys
And mind alone feels fancies and pourtrays.

John Clare
1793 - 1864

June ~ the sixth month of the year but the fourth month in the old Roman calendar. Ovid sayes June was named after the Goddess Juno
"Junius a juvenum nomine dictus" Ovid.

It was the Sear monath (Dry month) of the Saxons.

~ Junius the month of Juno ~

Juno ~ chief Roman Goddess worshiped by women in all life's crises.

June

"June brings tulips, lilies, roses;
Fills the children's hands with posies."

"June damp and warm
Does the farmer no harm"

"All things into tune
A misty May and heat in June."

"A dripping June keeps all in tune."

"Flaming June"

Whitsuntide

In the Church calendar, Ascension Day comes forty days after Easter. Ten days after Ascension day comes Whitsuntide. WhitSunday or 'White Sunday'. In the primitive Church the newly Baptised wore white from Easter to Pentecost and were called alba'ti (white robed). The last of the Sundays which was also the chief festival, was called 'Domin'ica in Albia (Sunday in White). It is also said that it is called 'Wit' or 'Wisdom' Sunday as it was the day on which the Apostles were filled with wisdom by the Holy Ghost.

"This day Wit-sonday is cald,
For wisdom and wit serene fald,
Was zonen to the Apostles as this day."
(Cambr. Univ. Mss. Dd i, 1 p 234)

Miracle and Mystery plays were performed at Whitsuntide.
Mystery plays were stories about the life of Christ.
Miracle plays dealt with other parts of the Scriptures or
with the life of a Saint.

Morris dancers may be seen at Whitsuntide. The stamping and jumping of their dances was intended to bring the crops out of the ground. The bells attached to their costumes were intended to wake the earth spirit or to drive away evil demons. Morris dancing was brought to England in the reign of Edward III. when John of Gaunt returned from Spain. Bells were jingled and swords were clashed. It was a military dance of the Moors or Moriscos, in which five men and a boy engaged; the boy wore a morione or head-piece and was called Mad Morion – Maid Ma'rian.

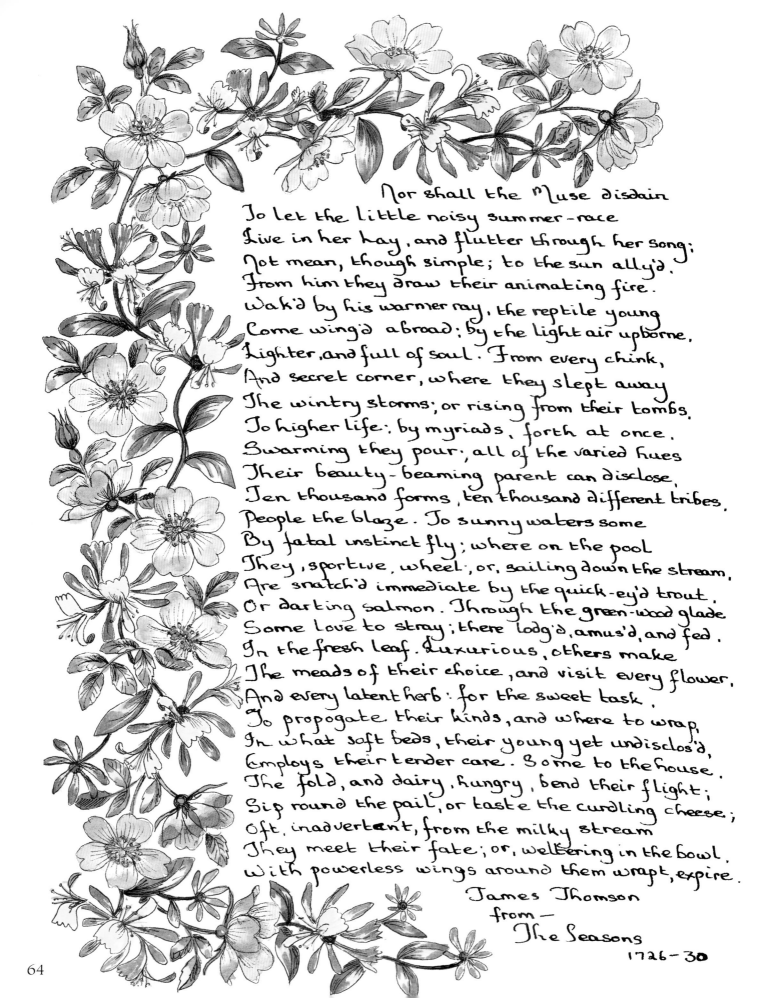

Nor shall the Muse disdain
To let the little noisy summer-race
Live in her hay, and flutter through her song;
Not mean, though simple; to the sun ally'd,
From him they draw their animating fire.
Wak'd by his warmer ray, the reptile young
Come wing'd abroad; by the light air upborne,
Lighter, and full of soul. From every chink,
And secret corner, where they slept away
The wintry storms; or rising from their tombs,
To higher life; by myriads, forth at once,
Swarming they pour; all of the varied hues
Their beauty-beaming parent can disclose.
Ten thousand forms, ten thousand different tribes,
People the blaze. To sunny waters some
By fatal instinct fly; where on the pool
They, sportive, wheel; or, sailing down the stream,
Are snatch'd immediate by the quick-ey'd trout,
Or darting salmon. Through the green-wood glade
Some love to stray; there lodg'd, amus'd, and fed,
In the fresh leaf. Luxurious, others make
The meads of their choice, and visit every flower,
And every latent herb: for the sweet task,
To propogate their kinds, and where to wrap,
In what soft beds, their young yet undisclos'd,
Employs their tender care. Some to the house,
The fold, and dairy, hungry, bend their flight;
Sip round the pail, or taste the curdling cheese;
Oft, inadvertant, from the milky stream
They meet their fate; or, weltering in the bowl,
With powerless wings around them wrapt, expire.

James Thomson
from —
The Seasons
1726-30

64

June

St. John's Work - Hypericum 'Hidcote'.
Hypericaceae
Very conspicuous five petalled flowers
with prominent yellow stamens grow
on a small shrub with oval leaves.
Flowering from summer to autumn.
'Hypericum'..... said to be derived from
the Greek 'huper-eikon' = 'above an image'
as it was said to decorate idols.

Swan River Daisy - Brachycome iberidifolia
Compositae
A fairly fast growing, bushy annual plant
with slender stems and deeply cut leaves.
The small, daisy-like flower-heads are
fragrant and are produced from summer to
early autumn. Usually blue but also
white, pink, purple and mauve. Native
to Australia and New Zealand.
Brachycome ---- Greek - brachus — come =
short hair, alluding to the short pappus.

Bellflower - Campanula carpatica -
'Bressingham white' ~ Campanulaceae
A perennial plant which spreads into
large clumps bearing numerous open
cup-shaped white flowers in summer.
Flowers are born singly on slender,
unbranched stems and the plant has
a mass of bright green leaves of a
rounded form. Although a large genus
of the Northern Hemisphere, Campanula
come mainly from the Mediterranean regions.
'Campanula' ~ diminutive of 'campana' = bell.
 Campanula - Gratitude

Potentilla aurea
 Rosaceae
A genus of fully hardy, summer flowering
perennials and shrubs. This plant grows
to 18 or 24 inches high and bears stems
of yellow, open, five petalled flowers
with golden stamens. Leaves compound
digitate with five leaflets
Potentilla ---- Latin potens from its reputed
medicinal power.

66

Tree Mallow - Lavatera thuringiaca
'Barnsley' - Malvaceae
A new variety of mallow forming a
loose shrub up to six feet in height.
Soft, velvety, grey green leaves with
pale pink flowers with a blotched
deeper pink centre. Flowers from
summer through to autumn.
Lavatera ... after Lavater, the name of
two physicians of Zurich.

Mallow - Lavatera trimestris
 Malvaceae
A fast growing annual with erect
branching stems bearing oval, toothed
leaves and shallowly, trumpet-shaped
deep pink flowers from summer to early
autumn.
Malva Classical name from 'malakos':
soft, from their soft, downy leaves.
 Mallow - mildness

Nicotiana alata
 Solanaceae
An annual plant with hairy, sticky
stems and leaves which are simple and
entire. Flowers in colours from white
to mauve and red, stalked and tubular
with small bracts. Flowers carried in
long, loose spikes and scented at night.
Nicotiána after J. Nicot, the French
Consul in Portugal who introduced the
plant into Europe.

Virginian Stock - Malcolmia maritima
A fast growing, weak, straggling annual
with oval, greyish green leaves and
slender stems bearing four-petalled
white, pink or red flowers from spring
to autumn. Height up to eight inches.
Native to the Mediterranean and
 Asia
Malcolmia after W. Malcolm an
early English gardener

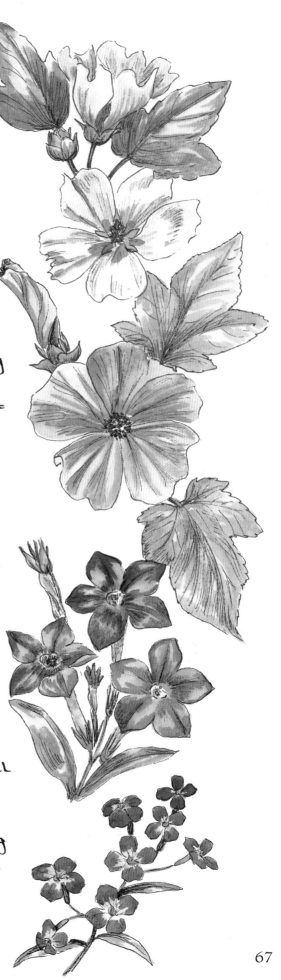

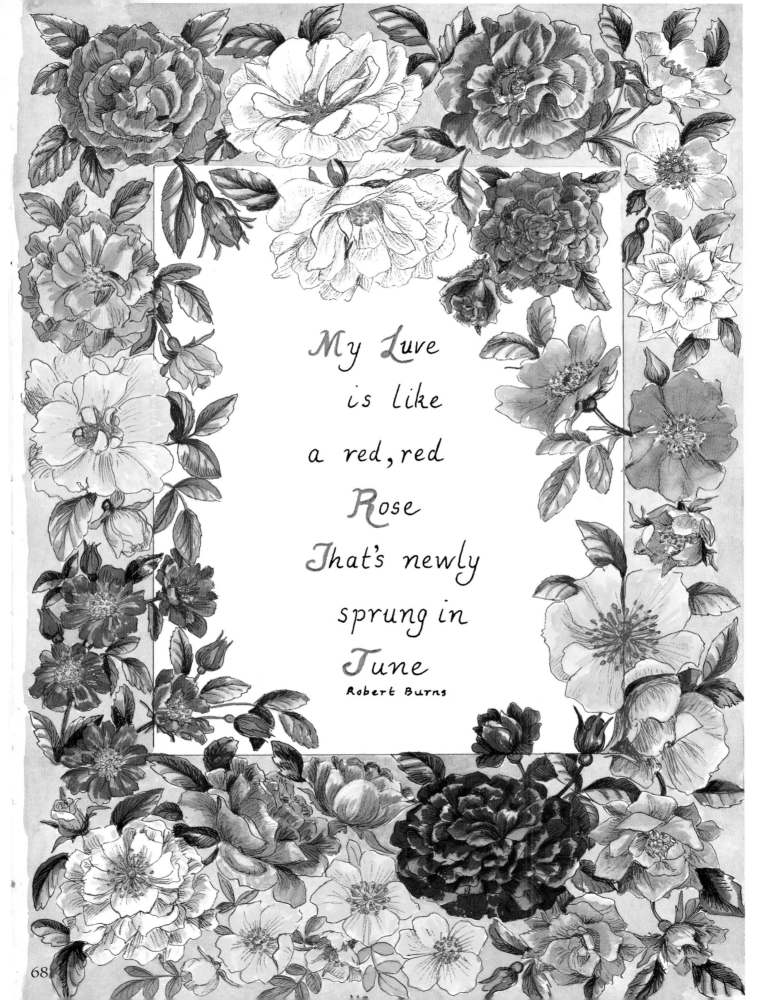

My Luve
is like
a red, red
Rose
That's newly
sprung in
June
Robert Burns

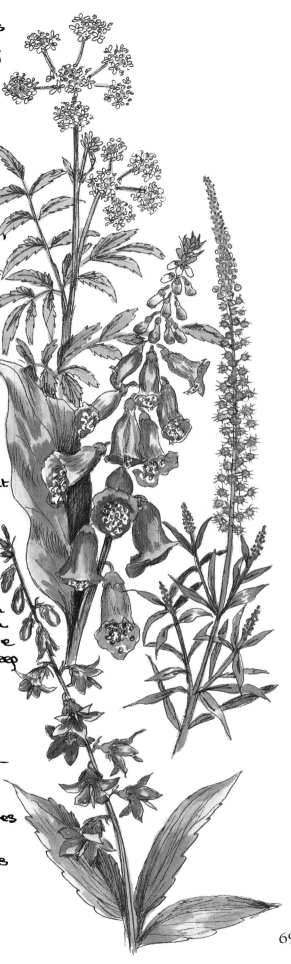

Cow Parsley — Anthriscus sylvestris
Umbelliferae

A very common plant along country lanes in late spring and early summer, flowering from April to June. Umbiliferous heads of small groups of tiny white flowers and deeply divided foliage.

Foxglove — Digitalis purpurea
Scrophulariaceae

A biennial herb producing a tall, erect stem from a rosette of basal leaves. Large, bell-shaped pinkish-mauve flowers, occasionally white, with purple spotting on a white ground. Common throughout Europe and the British Isles both in gardens and in the wild in hedgerows, woodland clearings and hillsides. In the 1770's William Withering discovered the plant's action in the treatment of dropsy and the plant has been widely used in medicine. The plant could get it's name from the fact the flowers resemble glove fingers. 'Fox' could be a corruption of 'folk's' from the 'little folk'. 'Glove' may derive from the Anglo Saxon word 'gliew' — a musical instrument with small bells. Digitalis from the Latin digitus — finger — German 'fingerhut' — thimble. All parts of the plant are extremely poisenous. It is said Foxgloves improve the health of other plants — If mixed in with cut flowers they will last longer — The same effect can also be achieved by adding Foxglove tea to the water. Take a handful of foxglove leaves and flowers, or just leaves and steep in water over night.
Foxglove — insincerity.

Dyer's Greenweed — Reseda Luteola
Residaceae

Erect stems up to 2-3 feet high. Leaves oblong and entire. Spikes of small greenish-yellow flowers. Common on stony or calcarous soils. Flowering June – August.

Creeping Bellflower — Campanula rapunculoides
Campanulaceae

Flowering June to August with spikes of deep blue bell-shaped flowers. Stems up to 1½" high.

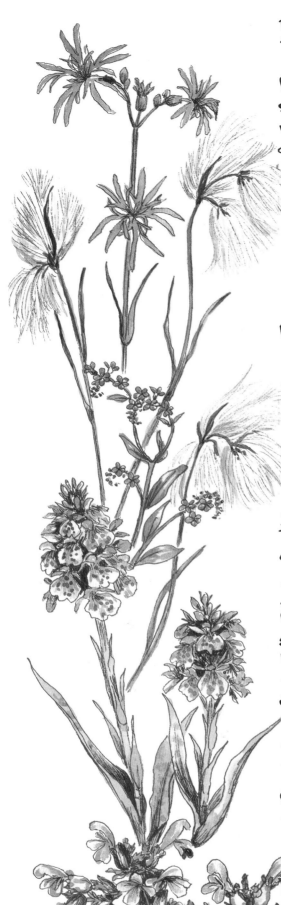

Ragged Robin ~ Lychnis flos-cuculi.
Caryophyllaceae

Rose coloured flowers of four spreading
segments giving a 'ragged' appearance.
Upper leaves narrow, broader below.
Flowers May and June in damp
meadows, marshes and fens.
Ragged Robin – Wit.

Cotton Grass ~ Eriophorum augustifolium
Cyperaceae

White tufted heads common in acid
bogs from May to June. At one time
the fluffy seed-heads were used as a
home-grown substitute for cotton-wool.

Lesser Water Forget-me-not.
Myosotis caespitosa ~ Boraginaceae
Small blue flowers on slender stems
found in damp places flowering from
May to August.

Common Spotted Orchid
Dactylorhiza fuchsii ~ Orchidaceae
From five to twelve lanceolate leaves,
usually spotted. Dense inflorescence
with from few to many flowers. Very
broad lip, three lobed with central lobe
small, triangular, shorter to as long as
lateral lobes. Very variable flowers,
pink, mauve, reddish or white with
darker markings. A very variable species
with many hybrid plants.

Restharrow ~ Ononis repens
Papilionaceae

Rhizomatous, procumbent stem, hairy
all round. Pink flowers common on
calcareous soils by the coast and
inland. Flowers from June to
September.

- - - - - -

Barnaby bright, Barnaby bright,
Longest day and shortest night.

14th June

Visited Buckfast Abbey in the morning in time for morning mass. Beautiful Church and everywhere a calm and serene atmosphere. Afterwards visited the Butterfly Farm and Otter Sanctuary which was very disappointing. Hardly any butterflies and few varieties ~unlike some I have visited where there are clouds of butterflies everywhere. A very hot day so stopped at the coast on the way back and then made a detour up through Cheddar Gorge and over the hills before rejoining the motorway.

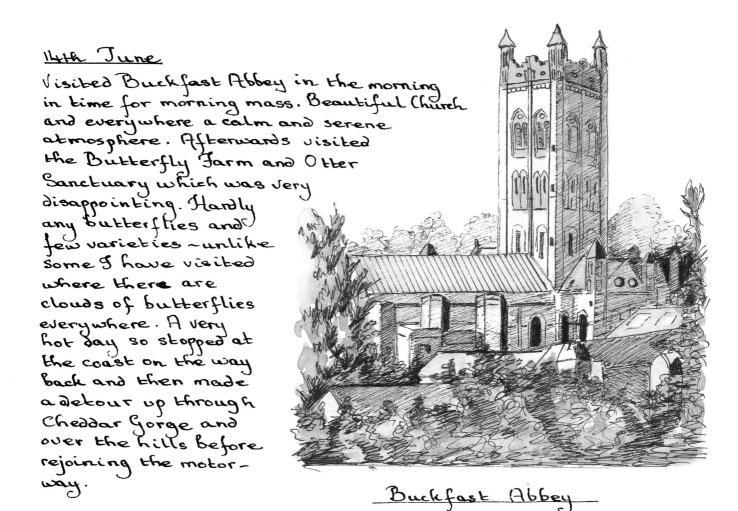

Buckfast Abbey

Buckfast Abbey

Buckfast was founded in 1018 as a monastery but the Cistercian monks were forced to leave after the dissolution of the monasteries by Henry VIII, in 1539. The monastery fell into decline and the buildings became derelict. In January 1907 under the the leadership of Abbot Anscar Vonier, work started to restore the monastery. The new buildings were based upon the original Cistertian foundations and the team consisted of only six monks with only one, Brother Peter, having any experience as a mason. The final capping stone was laid on the Abbey Church on 24th July 1937, making Buckfast the only monastery to have been rebuilt, largely in its original form, in a single lifetime. Buckfast now houses a working community of monks who aswell as their daily worship devote much of their time to teaching, stained glass window making, bee-keeping, farming, painting, carpentry and making the famous 'Buckfast Tonic Wine'.

The Cuckoo sings in May~

The Cuckoo sings in April~

The Cuckoo sings in Midsummer~

Midsummer Day
24th June – Feast of John the Baptist

On Midsummer Day, bonfires were lit to encourage fertility in livestock and crops and the cattle were driven through the flames to fend off diseases. If bracken seeds were gathered between 11 p.m and midnight and placed on a Bible or on a white sheet, they were said to give men magical powers.

"Cut thistles before St John and you'll have two instead of one."

Midsummer Men

The plant Orpine or 'Live Long' of the Sedum family, called because it lives so long when picked. Young girls would place the plant in a pot in the house on Midsummer's Eve so they could tell if their sweethearts were true. If the leaves bent to the right it was a sign of fidelity but if they bent to the left his heart was cold and faithless.

'But never on the day~

28th June

A beautifully hot and sunny day so decided to take a pic-nic up to the Moss Pool. Having expected it to be quite popular and busy on such an afternoon, we were surprised to find it totally deserted. We found a small, tree shrouded beach by the edge of the water and had no sooner made ourselves comfortable when we were faced with an invasion of ducks of all shapes and sizes, Mallards, Canada Geese and Shelducks. A pair of the Mallards' had a well grown brood of young with the mother being very protective towards the smallest of the chicks which still showed its juvenile down. It wasn't long before we were feeding them all with the bread we had taken and the more expectant and demanding they were, the more it encouraged us until one large goose, obviously seeing supplies were begining to run low, suddenly charged in and grabbed the remains of the loaf. This meant an immediate pursuit by all the other birds in an attempt

Mallard ~ Anas platyrhynchos
Probably the most familiar duck in the British Isles and the largest of the surface feeding ducks. The male has a conspicuous irridescent green head, white collar, maroon breast and black tail. The female is flecked brown and buff with a violet blue wing patch.

to grab a share of the crust before it completely disappeared and resulted in the victor charging across the water at high speed with all the others in hot pursuit after him. The problem was finally solved when the goose dropped the bread in its excitement and it sank to the bottom of the lake. On the way home we found a field full of enormously fat pigs basking in the sunshine in rotund mounds. One fitting his ample proportions into the food trough which obviously made a very comfortable bed. At the edge of the field we spotted a Kestrel finishing off the remains of a meal and stuffing the last torn pieces of grey fur into his beak he scuttled off into the long grass.

Kestrel - Falco tinnunculus.
A medium sized bird which can regularly be seen hovering above the roadside in search of prey chestnut coloured plumage - the male has grey head and tail with a black band at the end of the tail - underparts streaked dark brown - black. Piercing black eye surrounded by yellow ring.

— and so to bed ! —

July used to be the fifth month of the year before January and February were added to the calendar. It was named by Mark Anthony in honour of Julius Caesar and was once known as Quinctillis. The Anglo Saxons called it Maedmonath, the month when all the meadows were in flower and the cattle were turned out to feed.

July

'Hot July
brings cooling showers
Strawberries and Gillyflowers'.

'In July
Shear your rye'.

'Never Trust
a July sky'.

'If on the first of July it be rainy weather
It will rain more or less for four weeks together'.

'A swarm of bees in May is worth a load of hay.
A swarm of bees in June is worth a silver spoon.
A swarm of bees in July, worth not a fly'.

'The English winter ends in July and begins again in August'.

"Those who in July are wed must labour for their daily bread."

'Cut thistles in May ~ they'll grow in a day.
Cut thistles in June - they'll come again soon;
Cut thistles in July and they will surely die.'

Pansies

Salvia ~ Salvia spathacea
Labiatae

A tall, branched annual up to 18 inches high bearing spikes of brilliant red, two lipped, tubular flowers throughout the summer. The oval shaped leaves are serrated and mid-green in colour. Salvia from the Latin 'salvo' – to heal from the medicinal properties of some of the genus.

Red Salvia – Forever thine.

Germander ~ Teucrium-chamaedrys Rose
Labiatae

A hardy alpine well suited to growing in a trough. It is a spreading plant with dark green foliage, bearing many small spikes of rose-pink flowers from July to September

Teucrium after Teucer, King of Troy.

Impatiens 'Duet series'
Balsaminaceae

Fast growing bushy perennials grown as annuals with succulent but brittle stems up to twelve inches high bearing oval green leaves with flattish, spurred flowers in great profusion throughout the summer in shades from white, pink, cerise, red and mauve. Most of the genus are from tropical Asia and Africa with a few found in temperate climates.

Impatiens from the Latin word referring to the instant explosion of the ripe seed pods when touched.

Lobelia ~ Lobelia erinus
Campanulaceae

A slow growing spreading annual from four to eight inches high. Slender stems with lance-shaped to oval bright green leaves and an abundance of small, two lipped flowers born continuously throughout the summer and early autumn. A wide range of colours from white, blue and mauve.

Lobelia ~ Malevolence

A Contemplation upon Flowers.

Brave flowers ~ that I could gallant it like you,
And be as little vain!
You come abroad, and make a harmless show,
And to your beds of earth again.
You are not proud: you know your birth:
For your embroider'd garments are from earth.

You do obey your months and times, but I
Would have it ever Spring:
My fate would know no Winter, never die,
Nor think of such a thing.
O that I could my bed of earth but view
And smile, and look as cheerfully as you!

O teach me to see death and not to fear,
But rather to take truce!
How often have I seen you at a bier,
And there look fresh and spruce!
You fragrant flowers! then teach me, that my breath
Like yours may sweeten and perfume my death.

Henry King - Bishop of Chichester - 1592 - 1669

Californian Poppy ~ Eschscholzia californica.

A perennial plant that is usually grown as an annual. Grey-green, feathery leaves and four-petalled, cup-shaped flowers in bright orange, cream or yellow in summer and autumn. Native to Western North America Eschscholzia — after J.J. Eschscholtz, a German Doctor.

Cosmos ~ Cosmos 'Sensation' Compositae

A fairly fast growing, tall annual, growing to about three feet high with erect branched stems and very finely divided, feathery leaves. The large, open flowers are in shades of white pink or red and are borne throughout the summer and autumn.

Love Lies Bleeding ~ Amaranthus caudatus Amaranthaceae

Annual plants grown for their colourful foliage or for the long tassles of tiny, densely packed flowers. Pale green, oval leaves and long panicles of deep red flowers up to eighteen inches long, which are borne through the summer and autumn.

Love-lies-bleeding - Hopeless, not heartless.

Toad Flax ~ Linaria maroccana Scrophulariaceae

A fast growing annual with spikes of small ~ snap-dragon-like flowers in various shades of white, yellow, pink and purple. Slender, upright stems with pale-green, lance-shaped leaves. Grows up to about eight inches

Common Poppy ~ Corn Poppy ~ Papaver rhoeas
Papaveraceae

The bright red petals of the Common Poppy
are a well known sight along country
lanes and in cornfields in summer.
Probably one of our best known wild flowers
the brilliant red, four petalled flowers are
carried on slender, hairy stems. The lower
leaves are pinnately lobed and stalked,
with narrow toothed segments tipped with
bristles. The fruit is a hairless, ovoid
capsule. The common poppy is native to
Europe and Asia and can be found in the
wild in most parts of the British Isles. The
seeds which can be sprinkled on cakes and
bread also have the ability to lie dormant
in the soil for upwards of one hundred
years giving a brilliant display when
the ground is freshly disturbed after many
years. Very marked in this respect were
the battle-fields of the great wars and more
recently the new M40 motorway.

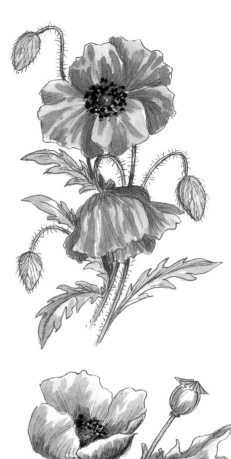

Red Poppy ~ Consolation

Opium Poppy ~ Papaver somniferum
Papaveraceae

Tall, occasionally hairy stems, branching
and bearing ovate to oblong, glossy, blue-
coloured leaves, pinnately lobed and toothed.
Flowers can be lilac, red or white and all
parts of the plant give off latex when cut
and all parts, except ripe seeds, are very
poisonous. Native to the Middle East,
Southeast Asia and Asia Minor it is now
naturalised through most of Europe. It is
however illegal to grow these poppies as a
crop without a licence, although the plant
can be found growing wild throughout the
British Isles flowering from June to August.

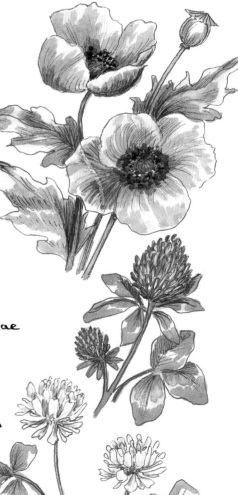

Red Clover ~ Trifolium pratense ~ Papilionaceae

A perennial plant with a branched stem and
trifoliate leaves with a characteristic white
crescent band on the upper surface. The
reddish purple flowers are arranged in dense
flowerheads and are an important source of
nectar for bees. Common throughout the British
Isles. Also cultivated for animal fodder and to
enrich the soil.

Red Clover ~ Industry

White Clover ~ Trifolium repens ~ Papilionaceae

A perennial plant with creeping stems and
trifoliate leaves, very occasionally four leaved
clovers are found which are reputed to be very
lucky! Flowers are creamy white ~ tinged pink
in a solitary densehead. After fertilisation, the
flowers go brown and turn down. Clover is an important
source of nectar for bees and can yield up to 100 kg
of honey per hectare.

White Clover ~ Think of me.

79

Haymaking

After night's thunder far away had rolled
The fiery day had a kernal sweet of cold,
And in the perfect blue the clouds uncurled,
Like the first gods before they made the world
And misery, swimming the stormless sea
In beauty and in divine gaiety.
The smooth white empty road was lightly strewn
With leaves — the holly's Autumn falls in June —
And fir cones standing stiff up in the heat.
The mill-foot water tumbled white and lit
With tossing crystals, happier than any crowd
Of children pouring out of school aloud.
And in the little thickets where a sleeper
Forever might lie lost, the nettle creeper
And garden warbler sang unceasingly;
While over them shrill shrieked in his fierce glee
The swift with wings and tail as sharp and narrow
As if the bow had flown off with the arrow.
Only the scent of woodbine and hay new-mown
Travelled the road. In the field sloping down,
Park-like, to where its willows showed the brook
Haymakers rested. The tosser lay forsook
Out in the sun; and the long waggon stood
Without its team: it seemed it never would
Move from the shadow of that single yew.
The team, as still, until their task was due,
Beside the labourers enjoyed the shade
That three squat oaks mid-field together made
Upon a circle of grass and weed uncut,
And on the hollow, once a chalk-pit, but
Now brimmed with nut and elder-flower so clean.
The men leaned on their rakes, about to begin,
But still. And all were silent. All was old,
This morning time, with a great age untold,
Older than Clare and Cowper, Morland and Crome,
Than, at the field's far edge, the farmer's home,
A white house crouched at the foot of a great tree.
Under the heavens that know not what years be
The men, the beasts, the trees, the implements
Uttered even what they will in times far hence —
All of us gone out of the reach of change —
Immortal in a picture of an old grange.

Edward Thomas – 1915

Go, For they call you, Shepherd, from the hill;
Go, Shepherd, and untie the wattled cotes:
No longer leave thy wistful flock unfed,
Nor let thy bawling fellows rack their throats,
Nor the cropp'd grasses shoot another head.
But when the fields are still,
And the tired men and dogs all gone to rest,
And only the white sheep are sometimes seen
Cross and recross the strips of moon-blanched green;
Come, Shepherd, and again renew the quest.

Here, where the reaper was at work of late,
In this high field's dark corner, where he leaves
His coat, his basket, and his earthen cruise,
And in the sun all morning binds the sheaves,
Then here, at noon, comes back his stores to use;
Here will I sit and wait,
While to my ear from uplands far away
The bleating of the folded flocks is borne,
With distant cries of reapers in the corn—
All the live murmer of a summer's day.

Screen'd in this nook o'er the high, half reap'd field,
And here till sun-down, Shepherd will I be.
Through the thick corn the scarlet poppies peep,
And round green roots and yellowing stalks I see
Pale blue convolvulus in tendrils creep:
And air-swept lindens yield
Their scent, and rustle down their perfum'd showers
Of bloom on the bent grass where I am laid,
And bower me from the August sun with shade;
And the eye travel's down to Oxford's towers.....

Matthew Arnold
from the Scholar Gipsy
1853.

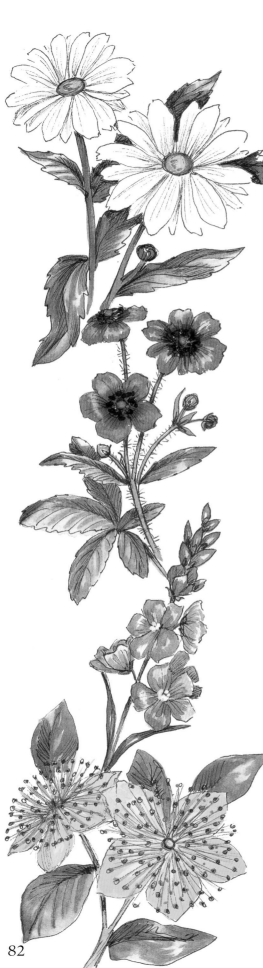

Marguerite ~ Chrysanthemum x superbum
Compositae

A woody stemmed, evergreen perennial
with creeping rootstock, which forms a
good sized bush of dark green, narrow
leaves and many large, white, daisy-
like flowers with yellow centres
throughout the summer. Grows up to
three feet in height. Also known as
'Shasta Daisy'.

Avens ~ Geum ~ Geum chiloense
Rosaceae

Flowering over a long period during summer
the Geum is a herbaceous perennial with
crowded, divided, evergreen leaves. The
flowers are carried in loose, branched,
panicles on long stalks and can be
red, yellow, orange or white in colour.
Geum.... said to be from the Greek
'geuo' = taste, but the flavour is not
obvious.

False Mallow~ Sidalcea malviflora
Malvaceae

A small species of North American plants
which contain two species from which most
of the garden varieties have been developed.
Sidalcea malviflora has rounded basal leaves
with the stem leaves divided into segments
usually toothed at the tips. The flowers
are carried in erect, graceful, spikes in
colours of pink, rose or purple. Flowers in
July and August.
Sidolcea.... from Sida and Alcea, two names
for Mallows.

Rose of Sharon ~ St John's Wort ~
Hypericum Calycinum ~ Hypericaceae

A semi-woody, sub-shrub which spreads
rapidly by means of underground runners.
The upright stems have oval-usually
evergreen leaves and carry many, large,
golden-yellow flowers up to three to
four inches across with many, showy,
stamens.

Common Mullein ~ Verbascum thapsus
Scrophulariaceae

Flowering from June to August, a
common plant of dry soil. In the first
year the plant produces a basal rosette
of leaves, followed in the second year
by a tall spike of closely packed, yellow
flowers. All parts of the plant are
covered in grey down and except for
the flowers, the plants are poisonous.
Mullein can be found growing wild
throughout Britain.
Verbascum from the Latin 'barbascum'
(barba = beard) after the downy foliage.
The downy leaves also give the plant
the name Mullein which comes from
the french, formerly Latin 'mollis' = soft.

Greater Knapweed ~ Centaurea scabiosa
Compositae

Found mainly on calcareous ground,
flowering from July to September.
Large purple flower-heads made up
of many florets with roughly hairy,
pale green bracts. Leaves deeply
divided, dark green. Found nearly all
over the Northern Hemisphere.
Centurea..... from 'Centaur' because
the Centaur, Chiron, when struck by
an Arrow from Hercules, cured the
wound by using this plant.
Centaury - Felicity.

Prickly Sow Thistle ~ Sonchus asper
Compositae

A tall plant, up to three or four feet
with spinous leaves with basal
auricles round and clasping the stem.
Loose heads of small yellow flowers.
A common weed of cultivated ground,
flowering from June to September.

Common Slender Eyebright ~
Euphrasia micrantha ~ Scrophulariaceae

A slender, erect plant with numerous
small leaves. White flowers, small,
with longer lower lip. Found throughout
Britain.

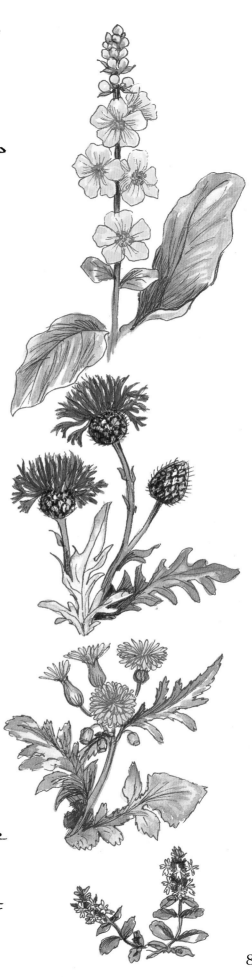

Pot-Pourri ~ Herbs ~ Lavendar ~ Oranges

One of the nicest ways of storing up summer memories is to collect sweetly smelling herbs and flowers and make a really old-fashioned Pot Pourri used for hundreds of years to perfume rooms. A 'home-made' mix is far superior to the modern mass-produced, commercial varieties, over perfumed with synthetic oils and ingredients. A true Pot Pourri should have a delicate, ellusive perfume that gently scents the air with a soothing and relaxing fragrance. They can be as simple or as complicated as you wish from a simple blend of rose petals to a complex mixture of assorted flower petals, herbs and spices ~ You can experiment with different mixtures and fragrances until you achieve your own personal favourite and then if you wish, keep your recipe a closely guarded secret as in days of old.

Collect your flowers on a dry morning and scatter the petals onto a sheet of paper in a warm, airy place. After a few days the petals will become papery and slightly brittle and they can then be stored in an air-tight container until you are ready to mix your Pot-Pourri. Gather together spices and essential oils:- allspice, cinnamon, cloves and oil of roses, sandalwood, peppermint, verbena and roses. Orris root powder makes a good 'fixative'. Add your ingredients a little at a time, mixing together in a large bowl until you achieve a perfume that is right for you. The mixture is then set to 'cure' in an air-tight tin for about a month. After this place bowls of Pot-Pourri around your rooms and enjoy the perfume and colour they give. If you want to preserve the fragrance for a longer period, place the Pot-Pourri into an attractive air-tight jar and lift the lid to scent the room when you feel like it.

A simple Rose Pot-Pourri

Take three or four handfuls of rose petals, dried and one handful of mock orange blossom, dried. Add two ounces of each of powdered orris root and ground coriander seed with one dessertspoonful of ground cinnamon. Gently mix together and place in an air-tight container for three or four weeks, shaking every two or three days, then enjoy the sweet aroma of roses.

and Lemons.

Dry some flowers whole or small flowers such as tiny pansies, rose buds and marigolds. These can be dried with silica gel crystals obtainable from chemists. Carefully place the flowers, face upwards on a thin layer of crystals and then gently cover with more crystals. Cover and keep in a warm place for a few days until dry then add a few 'whole' flowers to your dried petal mixture.

Place your Pot-Pourri mixture in tiny decorated sachets to place between linen and lingerie. Add larger quantities to small cushions for soothing relaxation. Make simple bags of lavendar :- Pick the heads of lavendar just before full bloom and make sure they are dry when picked. Hang upside down to dry. Remove the tiny buds and pop inside pretty muslin bags. Even simpler, just tie a few sprigs of lavendar together with a tiny bow of coloured ribbon or try a more complicated arrangement of plaited lavendar stalks and heads and coloured ribbon.

Many flowers and herbs can be dried by hanging bunches upside down in an airy shed or cupboard. When fully dry they can be arranged in suitable containers and how romantic to preserve your first bunch of red roses in this way ~ catch just before the heads begin to droop and you will have had the best of both worlds ~ fresh flowers in the vase and dried ones to keep with your memories.

Make tiny muslin bags and fill with sweetly smelling dried herbs to hang over the bath tap when running the water or take a selection of culinary herbs such as sage, thyme, marjoram, rosemary, parsley or bay and a mixture of the dried leaves into small muslin bags to make bouquet garni.

Although orange and lemon pomanders require a great deal of patience to make they are both attractive to look at as well as being deliciously perfumed. Divide the fruit into equal quarters by wrapping a narrow tape around, securing with a pin at the top and bottom. Take a large needle and pierce holes in the fruit pushing a clove into each hole as you pierce it ~ Follow the lines of the tape and don't leave any spaces between the cloves. When the fruit is completely covered place it in a bag with one tablespoonful of orris root powder and shake well until the fruit is well coated. Store, in the bag, for two or three weeks in a warm place. Remove the tape and decorate with ribbon tied around the spaces.

August received it's name from the Emperor Augustus who considered it to be his lucky month as most of his most fortunate events happened in this month. It used to be the six month of the year and was called Sextilis before it was renamed August. It was called Weodmonath by the Anglo-Saxons because of the growth at this time. August weather is often very variable ~ July and August being noted as the two wettest months of the year

August

"Dry August and warm does harvest no harm."

"August ripens,
September gathers in":

So many August fogs, so many winter mists

"August brings the sheaths of corn
Then the harvest home is born"

"All the tears St. Swithin can cry, St Bartlemy's mantle wipes them dry".

Fairest of months! ripe Summer's Queen
The hey-day of the year
With robes that gleam with sunny sheen,
Sweet August does appear.
~ R. Coombe Miller ~

"If 24th August be fair and clear, Then hope for a prosperous autumn that year".

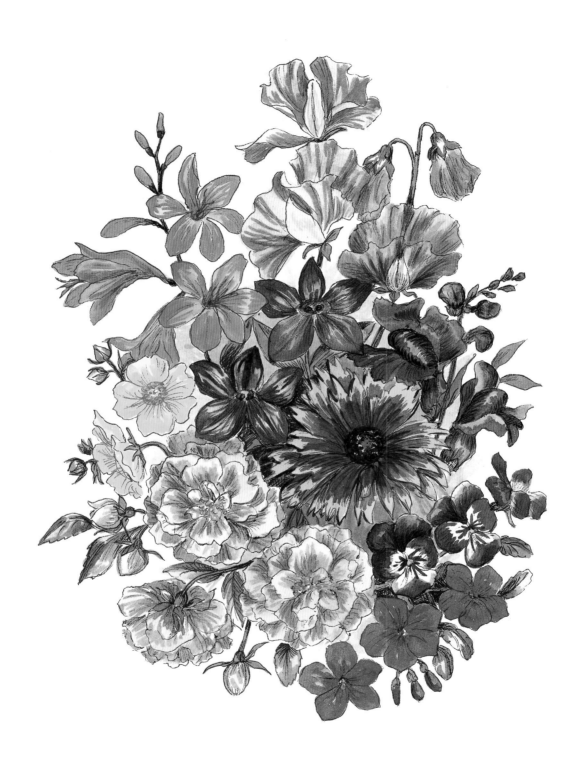

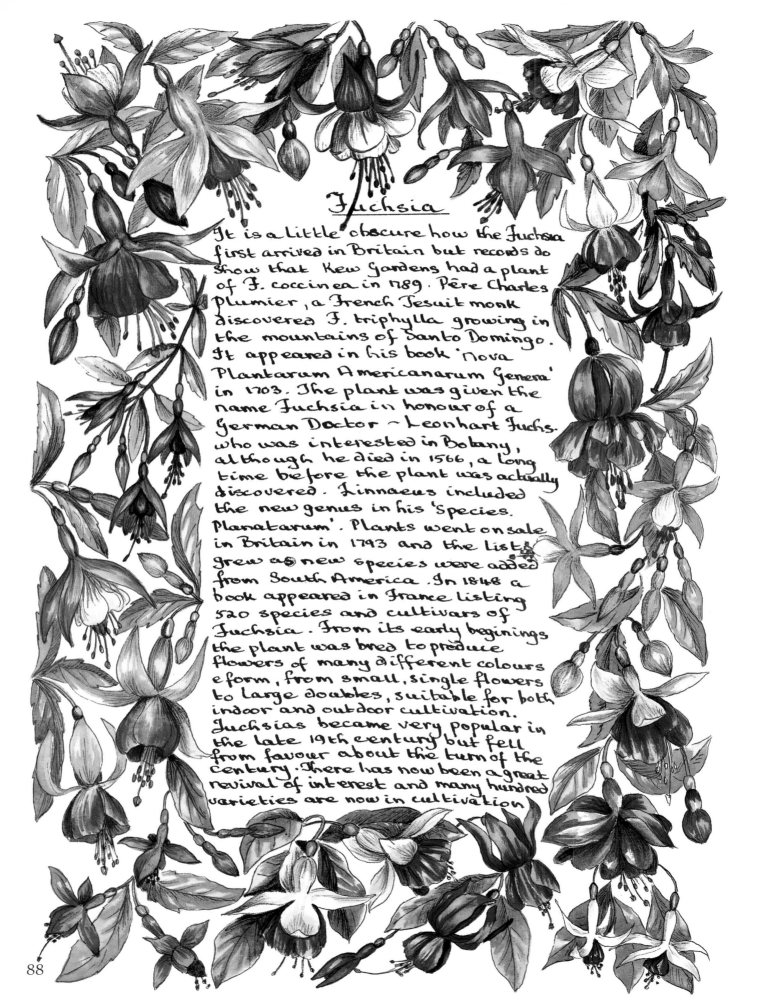

Fuchsia

It is a little obscure how the Fuchsia first arrived in Britain but records do show that Kew Gardens had a plant of F. coccinea in 1789. Pére Charles Plumier, a French Jesuit monk discovered F. triphylla growing in the mountains of Santo Domingo. It appeared in his book 'Nova Plantarum Americanarum Genera' in 1703. The plant was given the name Fuchsia in honour of a German Doctor ~ Leonhart Fuchs. who was interested in Botany, although he died in 1566, a long time before the plant was actually discovered. Linnaeus included the new genus in his 'Species Planatarum'. Plants went on sale in Britain in 1793 and the list grew as new species were added from South America. In 1848 a book appeared in France listing 520 species and cultivars of Fuchsia. From its early beginings the plant was bred to produce flowers of many different colours e form, from small, single flowers to large doubles, suitable for both indoor and outdoor cultivation. Fuchsias became very popular in the late 19th century but fell from favour about the turn of the century. There has now been a great revival of interest and many hundred varieties are now in cultivation

Corn Cockle - Agrostemma githago
Caryophyllaceae

A fast growing, slender stemmed annual
up to two to three feet tall. Pink
flowers up to three inches across and
lance-shaped, grey-green leaves.
Flowering in June and August, this was
once a common flower of cornfields
but now rare and grown in the
cultivated garden form.
 Corn Cockle - Duration.

Veronica - Veronica teucrium (Speedwell)
Scrophulariaceae

A herbaceous plant of a good blue colour
growing up to ten - twenty inches high.
Mat forming or upright with spikes
of saucer-shaped flowers in
the summer. Variable leaves, oval to
oblong, entire or deeply cut.
 Veronica - Fidelity.

Love-in-a-mist ~ Fennel Flower
Nigella damascena - 'Persian Jewel'
Ranunculaceae

Native to the Mediterranean and
Western Asia these are annuals
growing up to one foot high. It can also
be grown as a biennial where it will
make a taller, stronger plant. The
flowers are in shades of white, blue
and mauve with very finely divided
foliage. The large seed pods are also
very decorative.

Nigella Latin 'niger' = black
because of the black seeds.
 Love-in-a-mist ~ Perplexity.

Godetia - Clarkia 'Princess series'
Onagraceae

Annual plants with open, frilled flowers
in shades of white, pink, salmon and
mauve. Native to America, the
flowers are named after C.H. Godet,
a Swiss botanist of the 19th century.

Verbena x hybrida — Verbenaceae

A slow growing perennial usually grown
as an annual with a wide colour range.
Bushy plants with dark green, lance-
shaped, serrated leaves and clusters of
small, tubular flowers throughout the
summer.
Verbena.... old Latin name.
Verbena ~ Red ~ Sensibility; white ~
pure and guileless.

Marigold ~ Pot Marigold ~ Calendula officinalis
Compositae

Native to Southern Europe this plant is
a common, cottage garden annual, easily
grown in Britain. The bright yellow to
orange, daisy like flowers can be single
or double and are in bloom from summer
to autumn. Basal leaves are stalked
and spathulate while the stem leaves
are alternate, sessile and lanceolate.
The solitary, terminal flowerheads are
followed by a rough, curved achene.
The plant has been cultivated since the
Middle Ages and can be grown to
flower at any time of the year.
Calendula.... from Latin 'Kalends' as it
flowers at all seasons.
 Marigold - grief, despair.

Astilbe 'Bressingham Beauty'
Saxifragaceae

A clump forming perennial growing up to
3 feet in height. Compound leaves with
pinnately compound leaflets. Stiff stems
bearing feathery panicles of numerous
small, massed flowers in a pyramidal
form. Native to North America, Japan and
the Himalayas, they prefer moist ground
Astilbe.... greek a-stilbe = not-shining
apparently from the dull white flowers of
the original types.

Candytuft — Iberis umbellata
Cruciferae

A fast growing, bushy annual with straight
stems and simple, lance-shaped leaves.
The small flowers are borne in flattened
heads in shades of white, pink, purple
and mauve in spring and summer.
Flowers are conspicuous as the 2 outer
petals are longer than the others. Native
to the Mountains of Europe & Asia Minor.
 Candytuft - Indifference

Hollyhock – Alcea rosea syn. Althaea rosea
Malvaceae

Originally from China, the Hollyhock
is a short-lived perennial, or biennial
with very tall spikes of double or
single flowers in a wide range of
colours from white and cream to
yellow, pink and red. The alternate,
palmate leaves are lobed and of a
rough texture. It is widely grown
as a garden plant aswell as being
cultivated for the pharmaceutical
industry. In flower from July to
September.
Alcea; Althaea from the Greek –
'althein' = to heal, referring to it's
healing properties.
 Hollyhock – Fecundity.

Lobelia 'Vedrariensis'
Campanulaceae
A clump forming perennial growing
up to 3 feet in height with spiked
racemes of two-lipped, deep purple
flowers and lance-shaped leaves.
Not fully hardy and needs winter
protection or preferably lifting for over-
wintering in a cold frame or greenhouse.
Lobelia from Matthew Lobel a
Flemish botanist.

Nemesia strumosa
Scrophulariaceae
Grown as half-hardy annuals these
brightly coloured plants carry loose
spikes or panicles of flowers in a
range of colours. Leaves are lance-
shaped, serrated and pale green. Grows
into a bushy plant ideal for bedding out
and a good cut flower.
Nemesia --- Greek name for a similar plant.

Nasturtium – Indian Cress
Tropaeolum majus – Tropaeolaceae

A fast growing, trailing bushy annual with
rounded leaves and brittle stems. Long
spurred, trumpet-shaped flowers in colours
of cream, yellow, red, orange and mahogany.
Self-seed freely.

Tropaeolum from Greek 'tropaion'
= trophy - refers to the shield-like leaves
of the common nasturtium (war trophies
of classical times consisted mainly of shields
of the enemy, hung on posts or trees)
Nasturtium – patriotism.

21st August

Over to Shrewsbury and then down to Church Stretton and up onto the Long Mynd. Church Stretton is a thriving little town, tucked between the folds of the hills, but as you drive up the Burway, the shops are left behind. Once over the cattle grid you are onto the Mynd itself. The houses stop abruptly and you could be in another world. The lush, green of trees and gardens gives way immediately to wild, rolling, barren, heather-clad hillside. Patches of gorse, bilberries and bracken spread across the short, smooth, cropped grass and outcrops of bare rock. Tiny springs form silver rivulets of water which seep and trickle down into the valley below, from boggy hollows, grown over with deep cushions of emerald green, star-studded moss. The sheep wander aimlessly across the hillside, leaving narrow, winding tracks of red earth between the deep purple tussocks of heather stretching away into the distance in a misty, mauve haze. The narrow road winds up and up, sharp corners showing a steep, precipitous drop down to the valley. I think the only way to cross the Long Mynd is by coming up this road and down the far side ~ never the other way round ~ then one feels safer, as the drop is always on the opposite side of the road! In the distance, gliders take off and land from the gliding field, right on top of the mountain. They sweep lazily around, like great, dark birds, floating on the rising currents of air. Taking the sign for Ratlinghope, the track swings off to the right before bumping over another cattle grid and weaving between cultivated ground. Then, the hillside opens out again while down below, the mist of a storm sweeps across the valley, obliterating the hills beyond. Joy cattle browse the tiny, patchwork fields and a tiny tractor moves slowly and silently, turning the brown earth. Off the hill once more, the road drops between deep banks of delicate grasses, threaded with hairbells and hawkweeds. A few patches of lady's bedstraw add a fine tracery of yellow between the nodding, blue hairbells that rustle together in the breeze. Down and down now, the twisted, wind-bent hawthorns giving way to higher, lusher hedges of hazel with green clad nuts hiding between the rounded leaves ~ a promise of autumn to come. Long tendrils of honeysuckle hang down from the branches, flowers white, cream and a deep, purple-red, wafting their delicious perfume along the narrow lane. Two tiny, grey kittens speedily disappear through a barn door as we pass and a dog's rump, with wildly wagging tail, sticks out from the thick tangle of grass and brambles at the base of the hedge, obviously scenting good hunting. Houses appear and people and then the main road again, with traffic racing home. We join the queue.

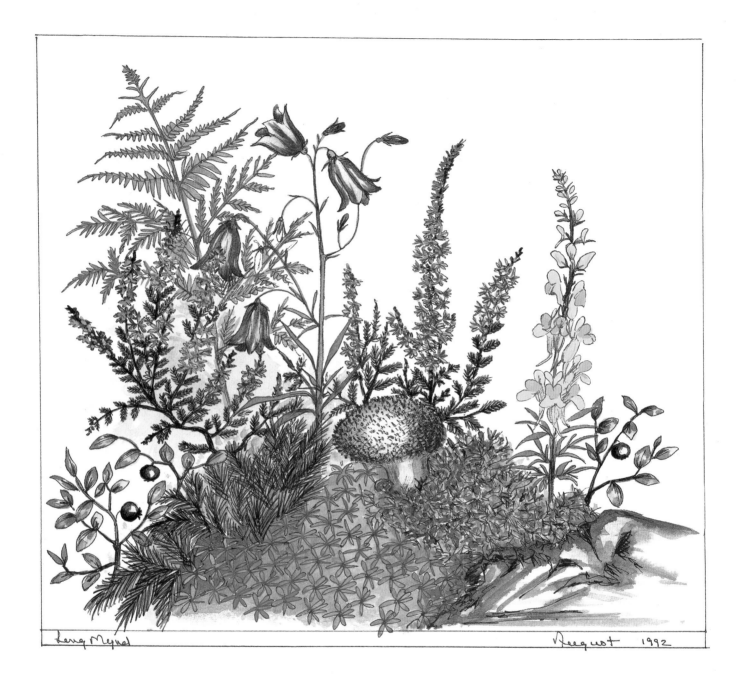

Long Meynel August 1992

"O to mount again where erst I haunted;
Where the old red hills are bird-enchanted.
 And the low green meadows
 Bright with sward;
And when even dies, the million-tinted,
And the night has come, and the planets glinted,
 Lo, the valley hollow
 Lamp-bestarred!"

 From: In the Highlands
 Robert Louis Stevenson

93

Purple Loosestrife ~ Willowstrife
Lythrum salicaria ~ Lythraceae

A summer flowering perennial of river banks,
ditches and marshes . Tall, tapering spikes
of purple flowers up to four feet high with
opposite leaves , heart-shaped at the
base of the plant and long, narrow
further up the stem .

Sea Radish ~ Raphanus maritimus
Cruciferae

A biennial plant found on sandy shores
and sea cliffs . Leaves well segmented
and pale yellow flowers with a
deeply constricted pod.

Samphire ~ Crithmum maritinum
Umbilliferae

A fleshy leaved plant growing up to
one foot high, common on sea cliffs on
the west, south and south East coasts.
Flowers from June to September. Fruit
corky — used as a vegetable, steamed and
served with melted butter .

Lesser Bindweed ~ Convolvulus arvensis.
Convolvulaceae

A perennial plant with climbing
stems and small pink or white
funnel-shaped flowers about one
inch in diameter. Flowers only
open in sunny weather. Leaves
arrow-shaped . A common plant of cultivated
soils .

Valerian ~ Common Valerian
Valeriana officinalis ~ Valerianaceae

A perennial plant with a short rhizome
and large root system with erect, furrowed
stems bearing dense terminal corymbs of
small funnel-shaped flowers in white or
pink. Leaves opposite with from seven to
thirteen ovate or lanceolate, toothed
leaflets. Native to Europe Valerian can be
found in most parts of the British Isles.
The plant was called Valeriana in the
ninth or tenth centuries though the
origin of the name is obscure- possibly
from Valerius an early herbalist, the
Roman province of Valeria or from the
Latin 'Valere' = to be healthy from it's
medicinal properties.
Valerian ~ An accomodating disposition

Ragwort ~ Senecio jacobaea
Compositae

Erect stems growing up to three feet
high with bright yellow, daisy-like
flower-heads in large corymbs.
Glaborous, lobed leaves, broadly toothed.
A very common plant, flowering over a
long period of time in neglected meadows
and roadside verges.

Common Centaury ~ Centaurium erythraea
Gentianaceae

An annual or biennial plant with an
erect stem, branching at the top, growing
from a basal rosette of oval, veined
leaves. Stem leaves are shorter and
narrower. The funnel-shaped flowers
are arranged in terminal cymes and are
rose-pink in colour. Growing throughout
Europe it is locally common in the British
Isles though rarer in Scotland. In flower
from June to October. 'Centaurium'
originates from the Greek myth where the
wound in the foot of Chiron was healed by
one of the centaurs, while 'erythraea',
meaning 'red' after the colour of the flowers

Common Milkwort ~ Polygala vulgaris
Polygalaceae

Small blue flowers on slender stems with
lanceolate leaves. The lower petal is
fringed and flowers can also be pink or
white. Common on dry pastures and
hillsides in late summer
Milkwort ~ Hermitage

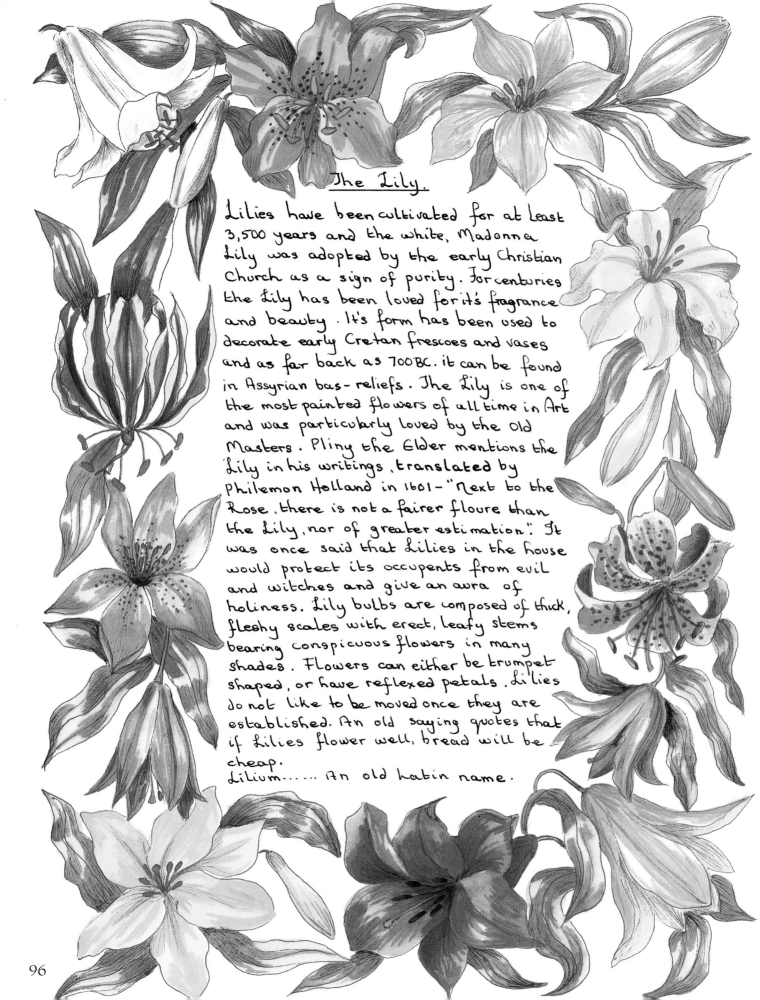

The Lily.

Lilies have been cultivated for at least 3,500 years and the white, Madonna Lily was adopted by the early Christian Church as a sign of purity. For centuries the Lily has been loved for it's fragrance and beauty. It's form has been used to decorate early Cretan frescoes and vases and as far back as 700 BC. it can be found in Assyrian bas-reliefs. The Lily is one of the most painted flowers of all time in Art and was particularly loved by the Old Masters. Pliny the Elder mentions the Lily in his writings, translated by Philemon Holland in 1601 - "Next to the Rose, there is not a fairer floure than the Lily, nor of greater estimation". It was once said that Lilies in the house would protect its occupents from evil and witches and give an aura of holiness. Lily bulbs are composed of thick, fleshy scales with erect, leafy stems bearing conspicuous flowers in many shades. Flowers can either be trumpet shaped, or have reflexed petals. Lilies do not like to be moved once they are established. An old saying quotes that if lilies flower well, bread will be cheap.
Lilium...... An old Latin name.

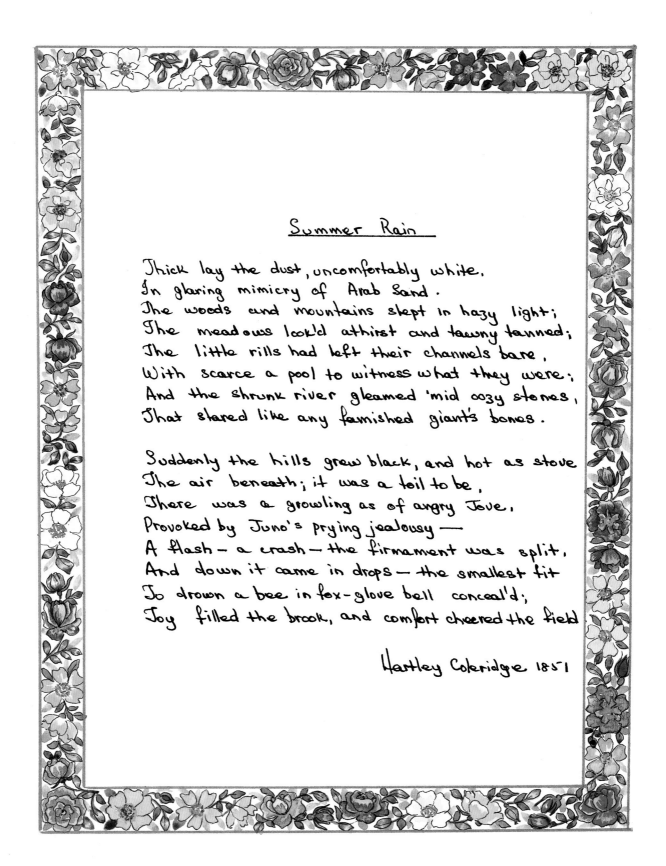

Summer Rain

Thick lay the dust, uncomfortably white,
In glaring mimicry of Arab Sand.
The woods and mountains slept in hazy light;
The meadows look'd athirst and tawny tanned;
The little rills had left their channels bare,
With scarce a pool to witness what they were;
And the shrunk river gleamed 'mid oozy stones,
That stared like any famished giant's bones.

Suddenly the hills grew black, and hot as stove
The air beneath; it was a toil to be,
There was a growling as of angry Jove,
Provoked by Juno's prying jealousy —
A flash — a crash — the firmament was split,
And down it came in drops — the smallest fit
To drown a bee in fox-glove bell conceal'd;
Joy filled the brook, and comfort cheered the field.

Hartley Coleridge 1851

Corn Dollies

Long gone are the days when the corn was cut by hand and tied into 'stooks', loaded onto the waggons and taken back to the barn. Now everything is mechanised but somehow the huge, great bales now scattered around the fields don't have the same romance about them as the golden, yellow sheaths. However, Corn Dollies are still very popular though they may not be viewed with as much superstition as they were! They originated around the last sheaf of corn in a field – when there was just enough to make a sheaf it was tied together while it still stood. The workers then threw their sickles at it so the corn would be cut down without any one person being responsible as it was considered very unlucky to cut the last ears of corn. When it was finally cut, it was shaped roughly into a human shape by tying and plaiting. It was dressed as a female with lots of ribbons and was called a 'corn dolly', 'kern baby' or 'corn maiden'. In some places more intricate shapes and patterns were made. These were supposed to hold the spirit of the corn until the next season and would be kept in the house through the winter until the next harvest. Different stories come from different parts of the country but the reasoning is the same to keep the corn spirit until next year. Demeter was the Greek Goddess of the corn ~ the Corn Mother~ Her daughter Persephone symbolised the mystery of the birth and death of the corn. Ceres, the Goddess of the corn was responsible for concealing the corn seed in the ground and bringing forth the ripe grain and the Ancient Egyptians worshipped the germination of seeds by their Goddess Isis. These ancient traditions linger on in the twisted and plaited shapes we weave today, though their origins are long forgotten

Horse Mushroom
Agaricus arvensis.

Large white caps up to 8 inches across, turning creamy-yellow with age. Tall, cylindrical stem with bulbous base with large membranous ring. Gills are white at first, turning flesh pink and then deepening to chocolate brown with age. White flesh, excellent to eat with a strong 'mushroom' flavour. Pick early in the morning and carry gill-side down to avoid particles of soil and grit embedding in the gills ~ Perfect after an early morning walk, fried with bacon!

Harvest Moon

The full moon that falls near harvest-time is called the 'Harvest Moon'. If it hangs high in the sky it will mean a poor harvest If fruit is gathered while the moon is on the wane it will last for a long time. If crops or fruit are left to lie in the moonlight for too long it is said they will rot more quickly but if potatoes are dug while the moon is full you will get a much bigger and better crop.

Harvest Festival

This is a fairly recent idea in the Church calendar and was started in 1843 by the Reverend R.S. Hawker of Morwestow in Cornwall. He called his parishioners together to give thanks for the harvest and the idea was soon copied and a harvest thanksgiving is held by most denominations and is an important annual festival often followed by a Harvest supper and sale. The churches and chapels are decorated with fruit, flowers, vegetables and corn and these, or the proceeds of the sale are donated to the needy.

September, the ninth month of the year but the seventh according to the old Roman calender — Septem being the seventh. It was called the 'gerst-monath or Barley month by the Anglo Saxons.

'September blows soft till the fruits' in the loft.'

'Fair on September first, fair for the month.'

Warm September brings the fruit.
Sportsmen then begin to shoot.

'Plant trees at Michaelmas and command them to grow
Set them at Candlemass and entreat them to grow.'

September dries up wells or breaks down bridges.'

Marry in September's shine,
 Your living will be rich and fine.'

St Matthew brings cold dew — September 21 - St Matthew.

Autumnal agues are long or mortal

September, the month of harvest home
There was great rejoicing when all the harvest was finished
and safely gathered in. As the last load was brought into the
rickyard the festivities began, songs were sung and a harvest
supper was held in the evening.

"Up! up! up! a merry harvest home
We have sowed, we have mowed;
We have carried our last load."

The spring is like a young maid
That does not know her mind.
The summer is a tyrant
Of most ungracious kind;
The Autumn is an old friend
That pleases all he can,
And brings the bearded barley
To glad the heart of man.

Christina Rossetti.

Now every day the bracken browner grows
Even the purple stars
Of clematis, that shone about the bars,
Grow browner; and the little autumn rose
Dons, for her rosy gown,
Sad weeds of brown.

Mary Coleridge.

Now falls the eve; and ere the morning sun,
Many a flower her sweet life will have lost,
Slain by the bitter frost,
Who slays the butterflies also, one by one,
The tiny beasts
That go about their business and their feasts.

17th September - St. Lambert's Day.

St. Lambert or Landebert lived in the seventh century and was a native of Maestricht.

"Be ready, as your lives shall answer it
At Coventry, upon St. Lambert's Day".
Shakespeare
Richard II - i - l.

18th September

Tremendous storms throughout the night rolling round and round with thunder, lightening and torrential rain. Great flashes of blue lightening which lit the garden like day-light.

'Thunder in September means a good harvest next year'.

19th September

Out for a walk and a beautiful swan flew directly overhead, strong, slow wingbeats and long neck outstretched.

Mute Swan - Cygnus olor

Adult, white with orange bill with black base and knob. Young, light brown. Nests at the water's edge on sticks reeds, weeds etc. Common throughout most of the British Isles & breeds in central and Northwest Europe to Estonia and Poland. Also across Eurasia from Northern Greece to Southeast Siberia. Majestic flight with loud wingbeats and very graceful on the water. Male - cob; Female - Pen; Young - cygnet.

21st September - St Matthew's Day - St. Matthew shuts up the bees.

"St Matthew brings the cold dew".

Woke in the night to hear a rustling behind the curtains - listened but could not make out what the noise was and eventually plucked up courage to switch the light on - swooping out from behind the curtains - a long eared bat fluttering round the room! It flew through into the dining room where it landed, suspended in a corner. Decided to open the door and hope it would find it's own way out which by morning it had!

Long Eared Bat
Plecotus auritus

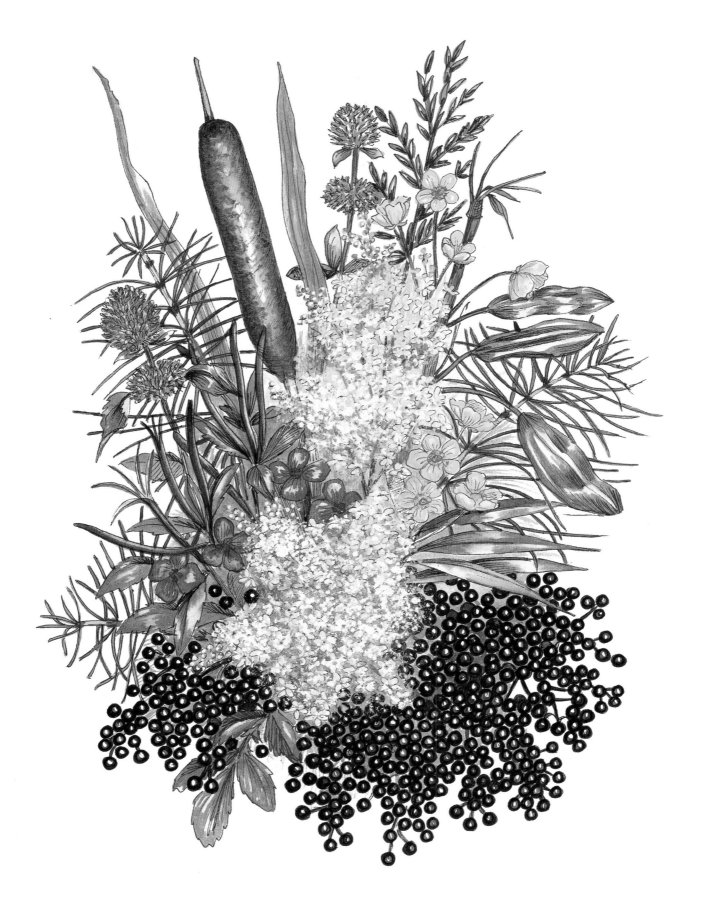

September

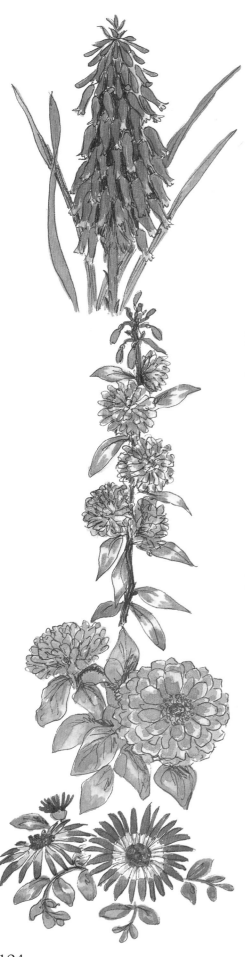

Red Hot Poker ~ Kniphofia linearifolia
Liliaceae or Aloeaceae

A tall growing perennial with brightly coloured,
orange flowers, opening from bright pinkish-red
buds. The flowers are crowded into a stiff,
upright spike with long tubular perianths with
short teeth. Numerous long, pointed leaves
which fold towards the ground, forming a thick
clump. The plants are native to South Africa
and there are many species and varieties.
Kniphofia named after Professor Kniphof.

Clarkia ~ Clarkia amoena ~
Onagraceae

A genus of fast growing annuals with thin,
upright stems up to 2 feet high bearing
single or double flowers in various shades
of pink, throughout the summer. The plant
is native to North America and there are now
many varieties in cultivation.
Clarkia after Captain W. Clark who was
part of the Lewis Expedition to the Rocky
Mountains.

Zinnia ~ Zinnia elegans ~
Compositae

Half-hardy annuals with large dahlia-like
flower-heads and pale green, oval to lance-
shaped leaves. Flowers come in a range of
colours from white and cream to yellow, red,
pink and purple. The plant makes excellent
cut flowers and is a native of Mexico.
Zinnia after J. G. Zinn a doctor from Goettingen
 Zinnia ... Thoughts of absent friends.

Ice Plant - Livingstone Daisy
Mesembryanthemum - Dorotheanthus bellidiformis
 Mesembryanthemum criniflorum - Aizoaceae
Succulent, prostrate annuals with fleshy, opposite
leaves and daisy-like flower heads in a
range of brilliant colours from white to yellow,
pink and red etc. The flowers only open in
bright sunlight and the plant needs continual
'dead-heading' to prolong it's flowering season.
Mesembryanthemum from the Greek 'mesos-hemera-
bruo-anthemom' = middle-day-bloom-flower as the flower
closes at night or in the shade.

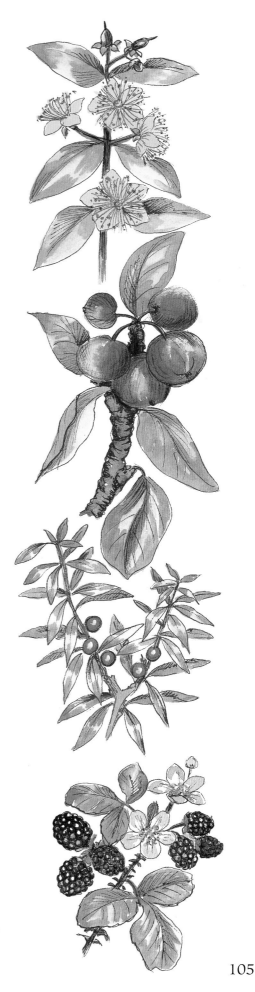

Tutsan - St. John's-Wort -
Hypericum androsaemum ~ Hypericaceae
A semi-shrubby plant which sends up
annual shoots up to five feet high. The
flower is characteristic with five yellow
petals and a crown of many stamens. The
fruit is a black, pulpy berry.
Hypericum.... derived from Greek
'huper-eikon' = above an image, from its
having been used to decorate idols

Crab Apple ~ Malus
Rosaceae
Small, often brightly coloured fruits
born in the autumn after the showy,
spring blossom. Very useful for
making preserves, jelly etc. aswell as
adding autumn colour to the garden.

Buckthorn ~ Sea Buckthorn
Hippophae rhamnoides - Elaeagnaceae
A deciduous shrub or small tree with
much branched, thorny twigs. The leaves
are alternate, linear to lanceolate, dark-
green above and silvery below. The greenish
flowers appear before the fruit and are
covered with scaly, brownish hairs. The
ovoid drupe-like fruit is bright orange
and in some parts is considered to be
poisenous.

Blackberry - Bramble - Rubus fruticosus
A deciduous shrub with arched, woody
stems and many prickles. The leaves are
stalked and have from three to five oval,
serrated leaflets. The underside of the
leaves are grey and hairy with prickles
along the veins. The white or pink
flowers are arranged in terminal racemes
and are born on second year stems. The
flowers are followed by a compound
fleshy drupe - the blackberry - found
abundantly in woods, scrubland and
hedgerows throughout the British
Isles and the genus consists of many species
and varieties spread throughout the world.
Rubus...latin name from ruber=red, referring to
the colour of the fruit.

105

<u>22nd September</u> - Autumnal Equinox - Equal Day and night.

<u>29th September</u> - Michaelmas Day - Feast of St. Michael the Archangel.

Michaelmas marks a natural ending to the farming year. It is one of the 'quarter days' when rents were paid, farms changed hands and people moved jobs. Traditionally a time for fairs and selling livestock, the festival is celebrated by a feast of goose - this is said to originate as Elizabeth 1st was eating goose when the news of the defeat of the Spanish Armada was brought to her, although the day the public thanksgiving was celebrated for the victory was 20th August 1588. Magistrates were chosen on this day as they were considered 'angels' and the Feast of St Michael and All Angels was the appropriate time to select them.

St Michael was prince of the celestial armies and God commanded him to drive the rebel angels out of heaven. In Christian art he is depicted as being very beautiful but having a severe countenance. He is clad in either armour or a white robe and carries a lance and shield. He is also represented holding scales with which to weigh the souls of the risen dead at the final judgement.

Country lore sayes that blackberries should not be picked after Michaelmas Day as they will have the Devil in them. As old Michaelmas Day was on 10th October it is said in some areas that brambles will not be 'spit on by the Devil' until then.

'Who so eats goose on Michaelmas Day
Shall never lack money his debts to pay'.

<u>30th September</u>

A miserable cold and wet month - Some torrential rain and very few fine days - following on from a wet and cold August means we have had a very short summer this year.

106

I've brought you nuts and hops;
And when the leaf drops, why, the walnut drops.
Crack your first nut and light your first fire,
Roast your first Chestnut crisp on the bar;
Make the logs sparkle, stir the blaze higher.
Logs are as cheery as sun or as star.
Logs we can find wherever we are.
Spring one soft day will open the leaves,
Spring one bright day will lure back the flowers;
Never fancy my whistling wind greaves,
Never fancy I've tears in my showers:
Dance, night and days! and dance on, my hours!

Christina Rossetti
1830~94

107

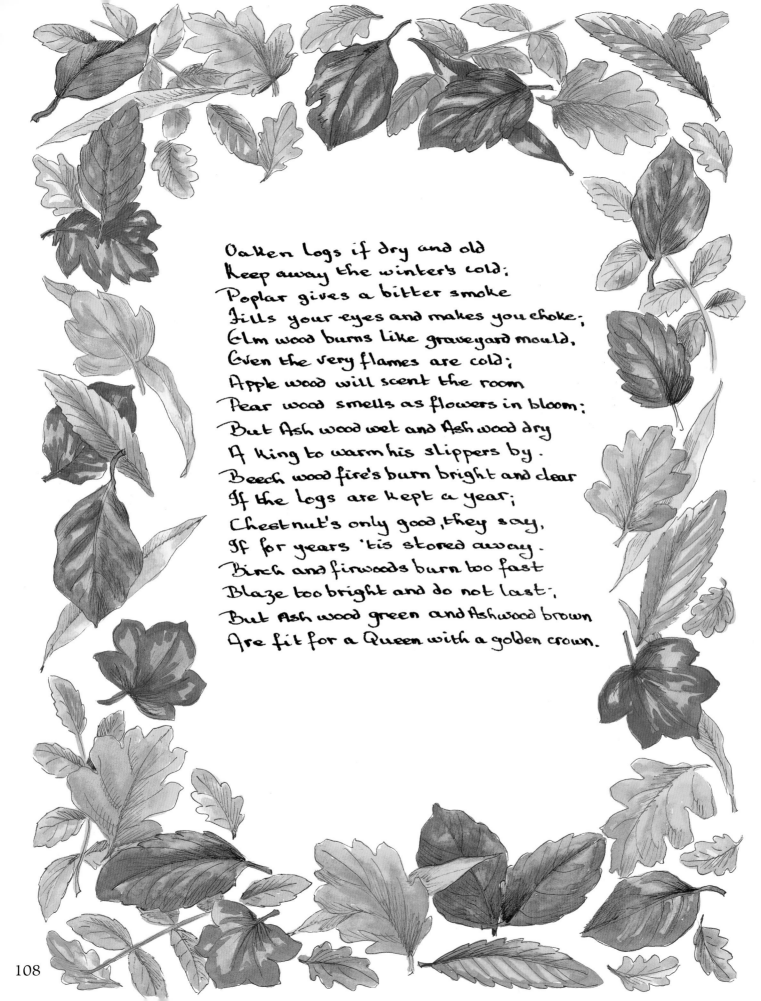

Oaken logs if dry and old
Keep away the winter's cold;
Poplar gives a bitter smoke
Fills your eyes and makes you choke;
Elm wood burns like graveyard mould,
Even the very flames are cold;
Apple wood will scent the room
Pear wood smells as flowers in bloom;
But Ash wood wet and Ash wood dry
A king to warm his slippers by.
Beech wood fire's burn bright and clear
If the logs are kept a year;
Chestnut's only good, they say,
If for years 'tis stored away.
Birch and firwoods burn too fast
Blaze too bright and do not last;
But Ash wood green and Ashwood brown
Are fit for a Queen with a golden crown.

Astrantia - Masterwork - Astrantia major
Umbiliferae

Native to Europe and Asia this clump forming
perennial has palmately lobed leaves and branched
stems carrying creamy-green, pink tinged flower
heads with coloured petaloid bracts. The flowers
are slightly 'papery' and dry well for flower
arranging.
Astrantia Greek 'aster' = star, meaning star-like.

Gazania ~ Gazania 'Daybreak'.
Compositae

A genus of perennials, usually grown as annuals and
much used for tubs and summer bedding. Lance-
shaped, long, narrow and pinnately cleft leaves
and large, daisy-like flower heads in a range of
colours from white to yellow, orange, pink and
bronze. The plants are native to South Africa.
Gazania after Th. v. Gaza an early Greek
scientist known for his translation of Theophrastus
and Aristotle.

Hibiscus — Hibiscus syriacus 'Red Heart'.
Malvaceae

An upright deciduous shrub with dark green, oval
lobed leaves and large, trumpet shaped flowers.
The white petals have wavy edges with a deep
red, central blotch.
Hibiscus an old Greek name reputedly derived
from 'Ibis' - the Egyptian god and 'isko' = like.
Hibiscus delicate beauty.

Flame Creeper - Flame Nasturtium -
Tropaeolum speciosum — Tropaeolaceae

A twining climber with brilliant red spurred
flowers and deeply lobed, bright green leaves.
Frost tender and prefers to be rooted in the
shade. The flowers are followed by blue
fruits with a surround of red calyces.

Tropaeolum from the Greek 'tropaion' = trophy
referring to the shield like leaves of the common
plant - nasturtium.
Nasturtium Patriotism.

Bindweed ~ Great Bindweed~ Hedge Bindweed
Convolvulus ~ Calystegia sepium ~ Bellbine
Syn. Convolvulus sepium
Convolvulaceae

A perennial, climbing plant with a
creeping rhizome and very long stems
which twine anticlockwise and branch
at the tips. The arrow-shaped, bluntly
lobed leaves are dark green above
and paler green below. The large, white,
funnel-shaped flowers are born on
the end of long stems from the leaf
axils and are amongst the largest
wild flowers in this country. Two, large
sepal-like bracts enclose the bud. The
flowers are very attractive to bees. A
very common plant, climbing through
hedges and widespread throughout
the British Isles though not so common
in the north. It can also be an invasive
and troublesome weed in gardens, impoverishing
the soil and strangling other plants growing
near to it.
'Calystegia' from two Greek words
'kalyx' = a cup and 'stege' = a covering
because of the enclosing bracts.
Bindweed ~ Insinuation

Kaffir Lily ~ Schizostylis coccinea ~
Iridaceae

A perennial plant with a spreading, fibrous
rhizome which can rapidly become congested
and needs regular division. Long, narrow,
pointed leaves and tall spikes, one to two
feet high, of pale pink or deep red flowers,
between long, green bracts. Native to
South Africa they flower in late summer
and autumn.
'Schizostylis' --- Greek 'schizo' = cleave, from
the forked styles

Chincherinchee ~ Ornithogalum thyrsoides
Liliaceae

Bulbs which flower in late summer and
bear dense spikes of cup-shaped white
flowers at the top of a fleshy stem twelve
to eighteen inches high. Long, strap-like
basal leaves. A good cut flower, lasting
for a long time once picked.

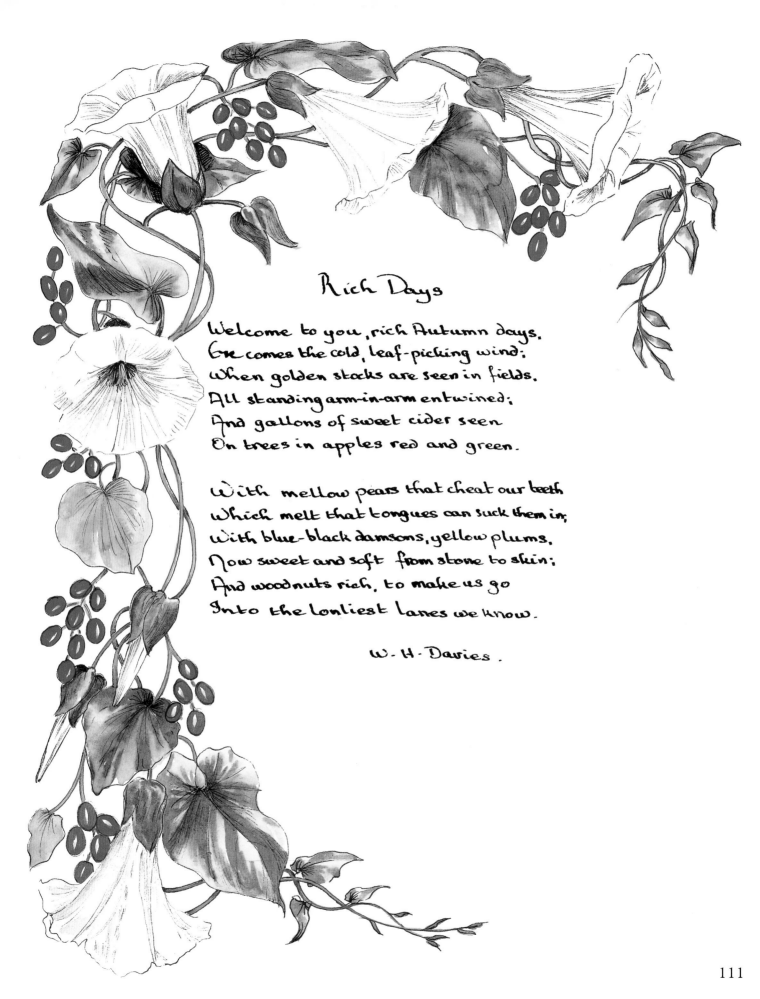

Rich Days

Welcome to you, rich Autumn days,
Ere comes the cold, leaf-picking wind;
When golden stocks are seen in fields,
All standing arm-in-arm entwined;
And gallons of sweet cider seen
On trees in apples red and green.

With mellow pears that cheat our teeth
Which melt that tongues can suck them in;
With blue-black damsons, yellow plums,
Now sweet and soft from stone to skin;
And woodnuts rich, to make us go
Into the lonliest lanes we know.

W. H. Davies.

111

October, now the tenth month of the year but originally the eighth month in the time of Romulus. This month was held sacred to Mars. It was known as the 'winter fylleth' to the Anglo Saxons as at this moon or 'fylleth', winter was said to begin. It was also called 'wyn monath', the month when the wine flows.

'Fresh October brings the pheasant
Then to gather nuts is pleasant'.

October

'A good October and a good blast
To blow the hog, acorn and mast'.

'In October dung your field
And your land it's wealth will yield'.

'If the fox barks long in October
there will be snow'

'If the oak wears it's leaves in October
it heralds a hard winter'.

'Much rain in October — much wind in December'

'There are always twenty one fine days in October'.

'Warm October — cold February'.
'By the first of March the crows begin to search,
By the first of April, they are sitting still,
By the first of May they are flown away,
Creeping greedy back again
With October wind and rain'.

"Then came October full of merry glee" ~ Spencer.

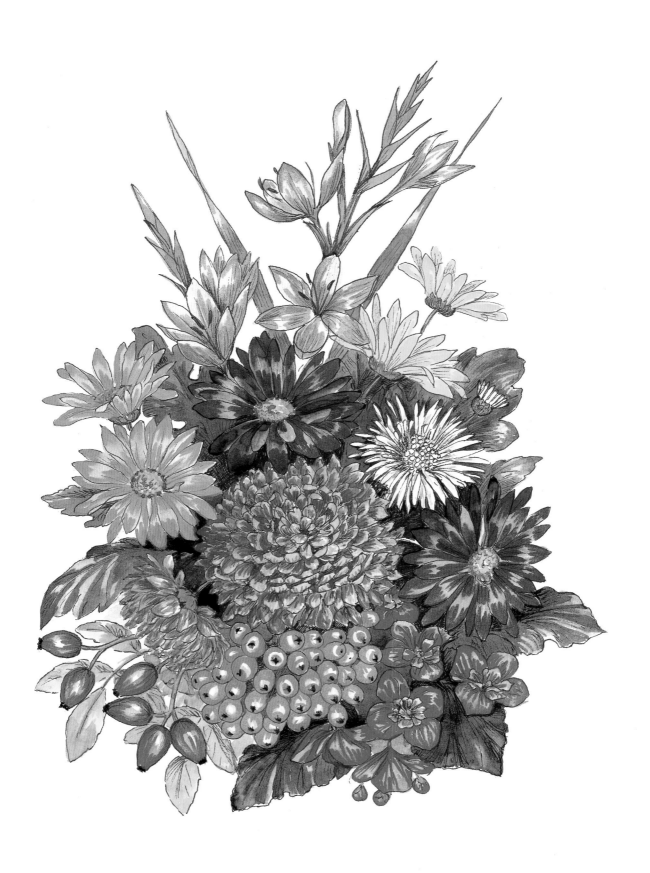

26th October

Weather not too bad, so out into the garden again. Finished cutting back all the plants and planted out the Wallflowers and Pansies.

27th October

Torrential rain!

28th October - Feast of Sts. Simon and Jude

This day has a reputation for rain! It is said always to rain on the Feast of Sts. Simon and Jude and it also marks the end of St. Luke's Little Summer which began on St. Luke's Day ~ 18th October. We have had a great deal of rain but these past few days have had one or two patches of sunshine scattered through ~ St Luke's Little Summer perhaps! Went down to Chetwynd firs and walked through the woods ~ Most of the leaves are down now, forming a sodden blanket on the muddy floor. The Beech trees are still ablaze with brilliant orange ~ gold leaves which seem to act like Beacons against the dark, starkness of the other trees. The chestnuts are no good at all this year, very few and far between and those you do find are very small and not worth having ~ we only managed to collect a few worth anything at all. Lots of puff balls under the trees this year, an olive green colour and found a branch covered with Many Zoned Polypore fungus.

Many Zoned Polypore ~ Coriolus versicolor

A fungus which is very common on deciduous wood and can be found throughout the year. The brackets form large tiered groups, concentrically zoned with very variable colours ranging from buff-cream to brown, slate blue and black-green. Several forms of this fungus have been noted.

114

Larch Bolete ~ Suillus grevillei.

A very common fungus found in late summer and autumn with larch trees. A shallowly convex cap in chrome-yellow to rusty-gold, shiny when dry. Stem yellow-brown with white or cream membranous ring which collapses to leave a broad ring zone. Pores small, yellow and angular becoming flushed brown. Edible.

Penny Bun ~ Cep ~ Boletus edulis

This is an excellent edible fungus and can regularly be found on sale in Continental markets, it is also used in many commercially produced mushroom soups. The convex cap is chestnut brown in colour with a netted, light coloured stem. White flesh with a pleasant aroma. Can be found in broad-leaved or mixed woodland or amongst conifers.

Shaggy Ink Cap ~ Lawyers Wig ~ Coprinus comatus

A tall, cylindrical cap, white with a cream to buff coloured centre breaking up into shaggy scales with the cap eventually melting into an inky fluid. Tall stem, white in colour with white ring which often falls to the base Gills starting white, then pink and finally black. Common in late summer and autumn on grass verges, gardens, rubbish tips and fields.

Fragile Russula ~ Russula fragilis

A common fungus of conifer or broad-leaved woodland, to be found in late summer to late autumn. A convex cap which flattens and becomes depressed, in a range of colours, purplish; red; olive green or yellow or a mixture of these. White stem thickening at the base and pale-coloured gills.

30th October

Bright and sunny but very cold. The winter jasmine is just coming into flower.

31st October ~ All Hallows' Eve ~ Samain

The night when ghosts and witches come out and the spirits of the dead are said to visit their former homes! Both Christians and Pagans followed this belief and lit bonfires at night in the hope they would give more light to the dying sun. The fires have now been moved to 5th November when we celebrate Bonfire Night. Hollowed out pumpkins are carved with a face and a candle is placed inside so the light will shine through the face to give an eerie glow. Children will play 'Trick or Treat' ~ particularly in America where the custom is widespread ~ If you don't respond to the knock on the door with a sweet or coin, you will get a trick played on you! In Scotland it is believed that those born on All Hallows' Eve have the gift of second sight and have power over the spirits

Also Nutcracker Night when lovers would set two nuts by the fireside. If they both burnt away completely all would be well between the lovers but if the nuts would not burn or they shot apart, the man was faithless.

All Hallows Summer

Called "L'été de St. Martin" by the French or St. Luke's Summer (St Luke's Day ~ 18th October) The days from the 9th October to 11th November are said to provide a second small summer around All-Hallows-Tide. Also called an 'Indian Summer'. In Henry VIth, Shakespeare refers to:—

"Farewell thou latter spring: Farewell, All-Hallows Summer!"

Song

Fall, leaves, fall; die, flowers away;
Lengthen night and shorten day;
Every leaf speaks bliss to me
Fluttering from the autumn tree.
I shall smile when wreaths of snow
Blossom where the rose should grow;
I shall sing when night's decay
Ushers in a drearier day

Emily Brontë
(1818 ~ 48)

116

Fly Agaric ~Amanita muscaria

A bright scarlet, convex, flattened to saucer-shaped cap with prominent white warts which can be washed off by rain to leave a smooth cap. White stem, swollen at the base and frequently covered with remnants of volval remains. White ring occasionally flushed yellow. A fungus which is quite common in deciduous and coniferous woodland during the autumn.

Plums and Custard ~ Tricholomopsis rutilans

A common fungus of late summer and autumn to be found on or near conifer stumps. A convex to bell-shaped cap, yellow in colour but densly covered with purple-red scales, solid at the centre but further apart nearer the rim. Stem similar but fewer scales. The fungus smells of rotten wood and tastes rather watery though is considered edible though not very appetizing.

Tawny Funnel Cap ~ Clitocybe flaccida

Clustered groups of buff or ochre coloured fungus, turning tawny with age, can be found in leaf debris in coniferous or deciduous woodland from summer to late winter. A flattened, convex cap turns to a deeper funnel shape with a paler coloured stem. Although edible this fungus is not very good to eat.

Jelly Babies ~ Leotia lubrica

Ochre yellow with greenish-coloured granular markings on the convex heads with lobed margins. Can be found in late summer and autumn under bracken or in damp, deciduous woodland.

117

He comes! he comes! in every breeze the Power
Of Philosophic Melancholy comes!
His near approach the sudden-starting tear,
The glowing cheek, the mild dejected air,
The soften'd feature, and the beating heart,
Pierc'd deep with many a virtuous pang, declare.
O'er all the soul his sacred influence breathes;
Inflames imagination; through the breast
Infuses every tenderness; and far
Beyond dim earth exalts the swelling thought.
Ten thousand thousand fleet ideas, such
As never mingled with the vulgar dream,
Crowd fast into the mind's creative eye.
As fast the correspondent passions rise,
As varied, and as high: Devotion rais'd
To rapture, and divine astonishment;
The love of Nature, unconfin'd, and, chief,
Of human race: the large ambitious wish,
To make them blest; the sigh for suffering worth
Lost in obscurity; the noble scorn
Of tyrant-pride; the fearless great resolve;
The wonder which the dying patriot draws,
Inspiring glory through remotest time;
Th' awaken'd throb for virtue, and for fame;
The sympathies of love, and friendship dear:
With all the social offspring of the heart.

James Thomson
from The Seasons
1726~30

118

Autumn

Osteospermum 'Cannington Roy'
Compositae

A straggling-clump-forming perennial with silvery-green leaves and daisy-like flowers in shades of white, blue, pink and mauve, with a darker centre. Prefers a warm, protected area, sun and a well drained soil and is frost to half-hardy.

Coleus - Coleus blumei -
Labiatae

Perennials which are grown as annuals for their attractively coloured leaves. Oval-pointed leaves have serrated edges and come in a range of mixed colours including cream-yellow-red-pink-green and purple. The plants produce spikes of small, blue flowers which should be removed.

Guelder Rose - Viburnum opulus
Caprifoliaceae

A strong growing, upright shrub or small tree with three-lobed leaves turning red in Autumn. Flattened heads of creamy-white flowers in June and July are followed by clusters of bright, red berries in Autumn.

Guelder Rose ---------- Winter or Age.

Oak — Quercus pedunculata - Quercus rober
Fagaceae

A common tree with its stout, rugged trunk and spreading branches. Leaves are dark-green, oblong and lobed and turn yellow in autumn. In flower during April and May, followed by the well known nuts or 'acorns' with husks that embrace the lower part of the nut.

Nerine - Nerine bowdenii
Amaryllidaceae

Makes a tremendous splash of colour in the garden in late autumn but does need protection. Native to South Africa the large, round bulbs send up narrow, strap-like leaves which last through until the following summer. The stem grows up to 2 feet in height and carries a terminal umbel of up to eight pale pink flowers with narrow petals about 3 inches long. There are a number of varieties but Nerine bowdenii is the only one which is hardy but even so requires a sunny, warm and sheltered position.

Plumbago - Leadwort - Plumbago auriculata
Plumbaginaceae

A fast growing, scrambling, climbing plant only hardy in warmer regions and usually grown as a greenhouse or conservatory plant. The woody stems have alternate long, oval leaves and trusses of pale bluey flowers with five spreading petals. Grows up to twenty feet.

Plumbago.... from the Latin plumbum = lead possibly from the colour.

Strawberry Tree - Arbutus unedo
Ericaceae

A spreading, evergreen shrub or tree with leathery, deep-green leaves and rough, brown bark. Terminal panicles of white or pink, small urn-shaped flowers are carried in autumn and winter when the previous seasons, red, strawberry-like fruits also ripen. Native to Europe and North America.

Strawberry Tree - Esteem, not love.

Anemone ~ Anemone coronaria
Ranunculaceae

Small, mishapen tubers which produce much divided, semi-erect leaves and stiff stems which bear large, cup shaped flowers in a wide range of bright colours from white, red, pink, purple and blue with a central 'boss of black' stamens. Grow well in the garden and make excellent cut flowers

Anémone.... old Greek name said to derive from anemos = wind but more likely to be from the old Phoenician deity, Na'aman who was the same as the Greek Adonis. The Arabs call the scarlet anemone 'shaqaiq an-nu'man' or the 'wounds of Na'aman'.

Garden anemone ~ Forsaken

121

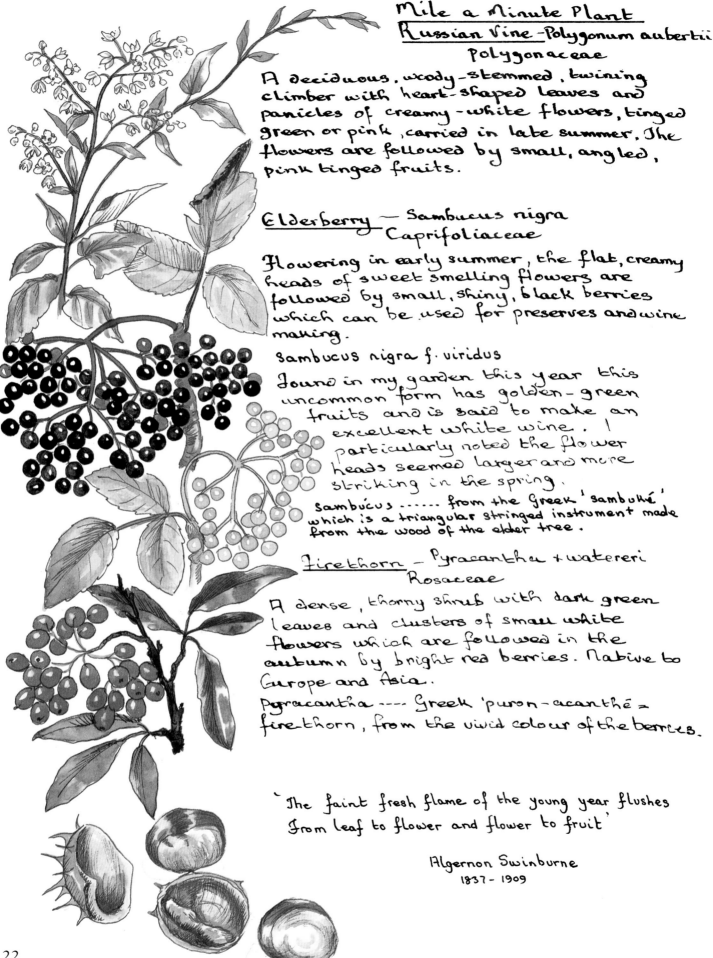

Mile a Minute Plant
Russian Vine - Polygonum aubertii
Polygonaceae

A deciduous, woody-stemmed, twining climber with heart-shaped leaves and panicles of creamy-white flowers, tinged green or pink, carried in late summer. The flowers are followed by small, angled, pink tinged fruits.

Elderberry — Sambucus nigra
Caprifoliaceae

Flowering in early summer, the flat, creamy heads of sweet smelling flowers are followed by small, shiny, black berries which can be used for preserves and wine making.

Sambucus nigra f. viridus

Found in my garden this year this uncommon form has golden-green fruits and is said to make an excellent white wine. I particularly noted the flower heads seemed larger and more striking in the spring.

Sambucus from the Greek 'sambuké' which is a triangular stringed instrument made from the wood of the elder tree.

Firethorn — Pyracantha x watereri
Rosaceae

A dense, thorny shrub with dark green leaves and clusters of small white flowers which are followed in the autumn by bright red berries. Native to Europe and Asia.

Pyracantha ---- Greek 'puron-acanthé = firethorn, from the vivid colour of the berries.

' The faint fresh flame of the young year flushes
From leaf to flower and flower to fruit '

Algernon Swinburne
1837 - 1909

122

Woody Nightshade - Bittersweet - Solanum dulcamara
Solanaceae

A perennial, climbing or trailing subshrub, growing in hedges, woods and wasteland. Leaves, alternate, ovate and entire or lobed at the base. Flowers have five spreading, recurved petals, mauve purple in colour with bright yellow anthers and are borne in terminal cymes in the axils of the upper leaves. The flowers are followed by bright red, ovoid fruits. The plant can be found throughout most of Europe and all parts of the plant are poisonous.

Nightshade - . - Truth.
Solanum from an old Latin name coming from 'solamen' = soothing, from the plants narcotic qualities.

Honeysuckle - Woodbine - Lonicera periclymenum
Caprifoliaceae

In flower from June to September, Honeysuckles can climb to a height of 30'. A common plant of woods and hedges with creamy-yellow, flushed pink, sweetly scented flowers in clusters, followed by deep red fruits.

Lonicera named after A. Lonicer, a German Botanist.
Honeysuckle - Woodbine Bonds of love; sweetness of disposition

Rowan - Mountain Ash - Sorbus aucuparia
Rosaceae

A deciduous, spreading tree up to 50' in height. The leaves made up of mid-green leaflets which turn yellow or red in autumn. Heads of creamy white flowers are borne in May and June followed by bright red fruits in late summer and autumn. Rowan is often planted as an ornamental tree. Its wood has been used for carving, the bark for dyeing and tanning and the berries were once used as bait to trap birds - 'aucuparia' = 'bird catching'. Fruits are used to make wine, conserves and syrups.
Mountain Ash Prudence

Sweet Chestnut - Chesten-nut - Castanea sativa
Fagaceae

A tall, spreading deciduous tree with glossy, dark green, oblong leaves which turn yellow and russet in autumn. The creamy yellow flowers are carried in spikes in summer and are followed by the brown, edible fruits 'chestnuts' which are contained in very spiny husks.

Castanea old Latin name.
chestnut Luxury
chestnut Tree Do me Justice

Weather

There are many old superstitions and sayings regarding the
these can prove to be extremely accurate. In fact, many country
rather than the modern, sophisticated and highly technical weat
elements are full of predictions and signs of the weather to

"Mackerel sky and mare's tails
Make lofty ships carry low sails".

"If woolly fleeces strew the heavenly way,
Be sure no rain disturbs the summer's day."

"When clouds appear like rocks and towers
The earth will be refreshed by frequent showers".

"Pale moon does rain,
Red moon does blow,
White moon does neither rain nor snow."

"When the stars begin to huddle,
The earth become's a puddle."

"Red sky at night, shepherds delight
Red sky in the morning, shepherds warning".

"Evening red and morning grey,
Two good signs for one fine day.
Evening grey and morning red,
Send the shepherd wet to bed."

"Grey mist at dawn,
The day will be warm."

"Rain before seven,
Fine before eleven."

"A sunshiny shower
Won't last half an hour."

"When it rains with the wind in the east,
It rains for twenty-four hours at least".

"Dew in the night,
Next day will be bright."

"A green Christmas
A white Easter."

"March
many weathers."

"When elder blossoms peep
You may sheer your sheep".

"Onion skin is very thin
Mild winter coming in
Onion skin is thick e tough
Winter will be cold e rough."

"A dry Lent
and a fertile year."

"If the cock goes crowing to bed,
He'll certainly rise with a watery head."

"If the oak is out before the Ash
We will only get a splash
If the Ash is out before the oak
We will really get a soak."

"Many rains, many Rowans
Many Rowans, many grains."

"Avoid an Ash
It courts a flash."

124

Lore

weather, particularly amongst country people and, quite often, people would prefer to follow the old sayings and superstitions her forecasts which are so often wrong anyway! The natural come and many sayings date back for hundreds of years.

"When the wind is in the east
Then the fishes bite the least;
When the wind is in the west,
Then the fishes bite the best;
When the wind is in the north,
Then the fishes do come forth;
When the wind is in the south,
It blows the bait in the fishe's mouth".

"When the bees crowd out of the hive
It is good to be alive,
But when they crowd the hive again
Sure sign of thunder and of rain."

"Easter is snow, Christmas is mud,
Christmas is snow, Easter is mud."

"If it rains on Easter Day
'Twill bring good grass but not good hay".

"If it thunders on All Fools Day
Expect good crops of corn and hay."

"If swallows fly high,
The weather be dry".

"A warm January means a cold May".

"All the months of all the year
Curse a fine Februeer."

"A dry March, wet April and cool May,
Fill barn and cellar and bring much hay".

"N'er cast a clout till May is out."

"A wet June means a dry September".

"Never trust a July sky".

"So many August fogs,
So many winter mists".

"Fair on 1st September,
Fair for the month."

"If the oak holds it's leaves
in October,
It heralds a hard winter."

"A cold November
A warm Christmas".

"A green Yule makes a fat Kirk-yard."

"A round topped cloud
with flattened base
Carries rain-fall
In it's face."

"If the evening be grey and the morning red,
Ewes and lambs will go wet to bed."

"Dew in the night
Next day will be bright."

"If the sun goes pale to bed,
Rain tomorrow it is said."

"Sound travelling far e wide
A stormy day will betide."

November - the ninth month of the year in Roman times - Novem - latin - nine - It was the 'Blodmonath' of the Anglo-Saxons as it was the month of sacrifice when the cattle were slaughtered and the meat was preserved for the winter. It was also called 'Wind-monath' or Wind month when the fishermen drew their boats ashore and stopped fishing until the following spring.

'November take flail
Let ships no more sail'.

Dovember

'Dull November brings the blast
Then the leaves are falling fast'.

'A cold November, a warm Christmas'

'If there's ice in November that will bear a duck
There'll be nothing after but sludge and muck'.

'If flowers are in bloom in late autumn
a bad winter will follow'.

The 11th November marked the begining of winter

The Coming of Winter

I have news for you; the stag bells, winter snows
Summer has gone.
Wind high and cold, the sun low. short it's course.
The sea running high.
Deep red the bracken, it's shape is lost; the wild goose
has raised his accustomed cry.
Cold has seized the birds' wings; season of ice.
this is my news.

Anon - 9th century.

126

From The Garden ~ November 19th

To Autumn

Season of mists and mellow fruitfulness,
Close bosom-friend of the maturing sun;
Conspiring with him how to load and bless
With fruit the vines that round the thatch-eves run;
To bend with apples the moss'd cottage-trees,
And fill all fruit with ripeness to the core;
To swell the gourd, and plump the hazel shells
With a sweet kernel; to set budding more,
And still more, later flowers for the bees,
Until they think warm days will never cease,
For summer has o'er-brimmed their clammy cells.

Who has not seen the oft amid thy store?
Sometimes whoever seeks abroad may find
Thee sitting careless on a granary floor,
Thy hair soft-lifted by the winnowing wind;
Or on a half-reap'd furrow sound asleep,
Drows'd with the fume of poppies, while thy hook
Spares the next swath and all its twined flowers:
And sometimes like a gleaner thou dost keep
Steady thy laden head across a brook;
Or by a cyder-press, with patient look,
Thou watchest the last oozings hours by hours.

Where are the Song of Spring? Ay, where are they?
Think not of them, thou hast thy music too,—
While barred clouds bloom the soft-dying day,
And touch the stubble-plains with rosy hue;
Then in a wailful choir the small gnats mourn
Among the river sallows, borne aloft
Or sinking as the light wind lives or dies;
And full-grown lambs loud bleat from hilly bourn;
Hedge-crickets sing; and now with treble soft
The red-breast whistles from a garden-croft;
And gathering swallows twitter in the skies.

John Keats
1820.

All Saints Day
November 1st.

In the year 610, the Pope of Rome ordered that the heathen Pantheon should be turned into a Christian Church and this was to be dedicated to the honour of all martyrs. Originally, the festival of All Saints was held on May 1st, but in the year 834 it was changed to November 1st. It is also known as All Hallows – "Hallows" is from the Anglo-Saxon 'halig - (holy). The French call it Toussaint which we have translated to All Saints Day. Hallowmas is All Saints Festival.

All Souls Day
November 2nd

This was first instituted in the monastry of Clugny in 993, and is so called because on that day, the Roman Catholics seek to alleviate the suffering of souls in purgatory, by prayers and almsgiving. The tradition is that a pilgrim, returning from the Holy Land, was compelled by a storm, to land on a rocky island. Here he found a hermit who told him that among the cliffs on the island was an opening into the infernal regions through which huge flames appeared and the groans of the tormented could be clearly heard. The pilgrim told this to the abbot of Clugny, one Odilo, and the abbot appointed the following day, November 2nd, to be set apart for the benefit of all souls in purgatory.

These early November hours
That crimson the creeper's leaf across
Like a splash of blood, intense, abrupt,
O'er a shield; else gold from rim to boss
And lay it for show on the fairy-cupped
Elf-needled mat of moss.

Robert Browning.

129

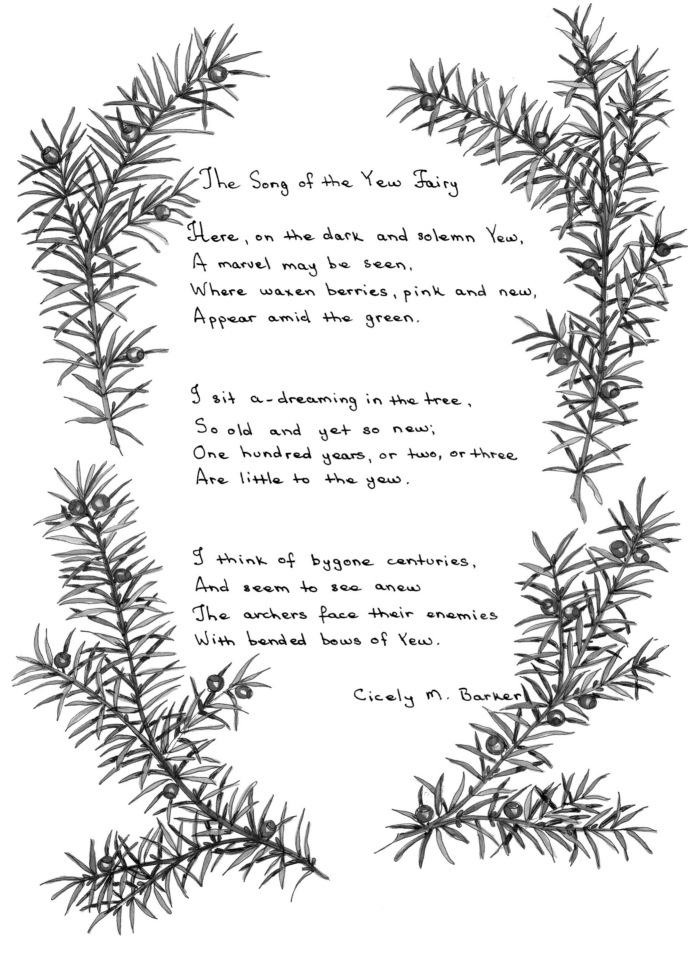

The Song of the Yew Fairy

Here, on the dark and solemn Yew,
A marvel may be seen,
Where waxen berries, pink and new,
Appear amid the green.

I sit a-dreaming in the tree,
So old and yet so new;
One hundred years, or two, or three
Are little to the yew.

I think of bygone centuries,
And seem to see anew
The archers face their enemies
With bended bows of Yew.

Cicely M. Barker

Pheasant - Phasianus colchicus

These birds have their origins east of Europe but introduction to Western Europe started early and they reached Britain

The cock pheasant is the only long-tailed

Plumage is variable from continuous interbreeding.

head, large red eye wattles and small

is coppery brown with fine black

white collar. Found in small

marshes and

during Roman times.
game bird.

Usually, glossy green
ear tufts, main plumage
markings. Many have
woods, hedgerows,
agricultural land.

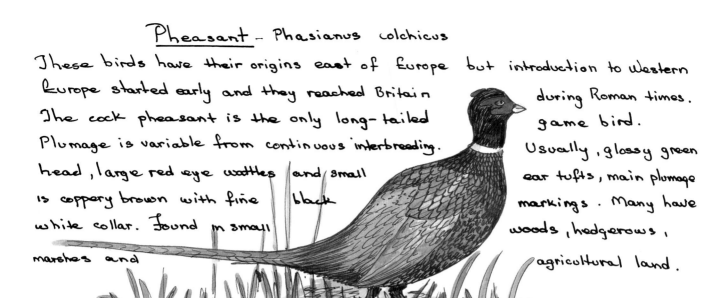

Partridge - perdix perdix

Smallest of the European partridges.

and throat, grey and chestnut

and greyish legs. Likes a wide variety

of open country, heaths, agricultural land etc.

Orange brown face
barring on flanks

Grey Heron - Ardea cinerea

The largest European heron, long bill, neck
and legs. Mainly grey colouring
with slender black plumes on crown and
black streaks on neck and breast.
Shallow water, fresh & salt.

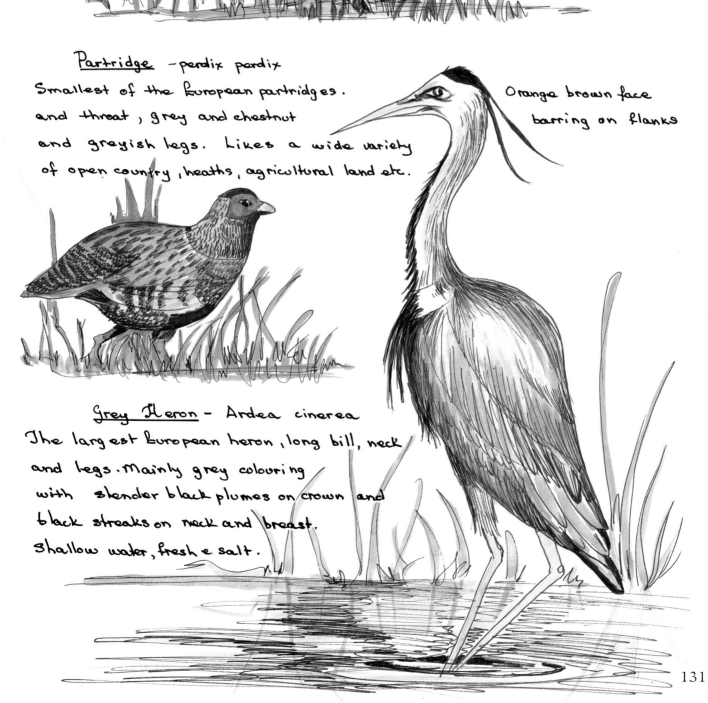

131

5th November
Guy Fawkes Night.

The Gunpowder plot was originated by Robert Catesby and a group of Roman Catholics in an attempt to destroy James 1st together with the Lords and Commons when they were assembled for the opening of Parliament on the 5th November 1605. It was to be achieved by means of gunpowder when the king went in person to open parliament. Guy Fawkes was to fire the powder, but the plot was discovered and they were surprised in the cellars of Parliament House. Although they had been discovered, Guy Fawkes persisted and was captured. We celebrate this event by fireworks and bonfires on which an effigy of Guy Fawkes is burnt. Guy Fawkes was the servant of a Mr. Percy and went under the name of John Johnstone. His real name was Guido Fawkes.

6th November
At last, after all the rain and cold weather, we have a much milder and a sunny day!

8th November
Still quite pleasant and managed to get out into the garden. Clearing up the last of the plants and sweeping up the leaves which seem to have smothered everything. Also cut back the bed on the drive a little further and moved a few more barrows of soil but it is hard work as it is a mass of old tree roots. The wysteria is a mass of yellow-gold leaves and has climbed all over the roof of the house so will need cutting back hard as soon as possible.

Remembrance Day or 'Poppy Day'
The 11th day of the 11th month is Armistice Day. At 11am on this day we respect a two minutes silence to honour the dead of World War 1. This is now celebrated on the second Sunday in November or 'Remembrance Day' in which we honour the dead of both world wars. Memorial Services are held and it is sometimes called 'Poppy Day' because red Poppies are worn in memory of the battle fields which blossomed with a sea of red poppies. This phenomenon resulted from the ground being disturbed releasing the poppy seeds to the surface as they will lie dormant in the soil for up to 100 years.

Signs of Winter

Tis winter plain the images around
Protentious tell us of the closing year
Short grows the stupid day the moping fowl
Go roost at noon — upon the mossy barn
The thatcher hangs and lays the frequent yaun
Nudged close to stop the rain that drizzling falls
With scarce one interval of sunny sky
For weeks still leeking on that sulky gloom
Muggy and close a doubt twixt night and day
The sparrow rarely chirps the thresher pale
Twanks with sharp measured raps the weary frail
Thump after Thump right tiresome to the ear
The hedger lonesome brustles at his toil
And shepherds trudge the fields without a song

The cat runs races with her tail- the dog
Leaps oer the orchard hedge and knarls the grass
The swine run round and grunt and play with straw
Snatching out hasty mouthful. from the stack
Sudden upon the elm tree tops the crows
Unceremonious visit pays and croaks
Then swops away — from mossy barn the owl
Bobs hasty out-wheels round and scared as soon
As hastily retires— the ducks grow wild
And from the muddy pond fly up and wheel
A circle round the village and soon tired
Plunge in the pond again — the maids in haste
Snatch from the orchard hedge the mizled cloaths
And laughing hurry in to keep them dry

<div align="right">John Clare 1793—1864</div>

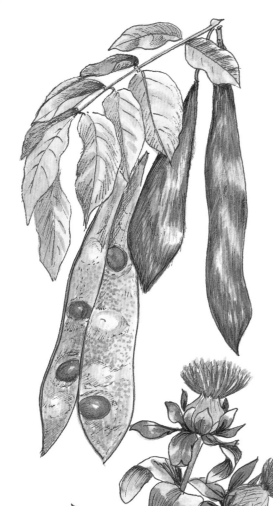

Wisteria
Leguminosae

This woody stemmed climber growing up to fifty feet or more with long racemes of pale lilac flowers will bare velvety, oblong pods in late summer and autumn containing oval seeds. These can be planted in autumn or spring but it will be some years before the plants will flower and even then, the flowers will probably be very poor and sparse.

The name 'wisteria' is now commonly accepted but older books spell this as 'wistaria' referring to the fact that it was originally spelt in error as 'wisteria' 'wistaria'..... after Caspar Wistar an American professor.

Safflower ~ False Saffron ~ Carthamus tinctorius
Compositae

Coarse growing annual growing up to 3' high. Stems branching above with ovate to lanceolate, spiny-toothed leaves. Thistle-like flower heads up to 1" across with green bracts and orange-yellow flowers.

Name derived from the Arabic, meaning 'paint' as the flower-heads yield an important pigment.

Scarlet Plume ~ Euphorbia fulgens
Euphorbiaceae

An evergreen shrub growing up to five feet in height with arching branches and elliptic to lance-shaped leaves up to four inches long. The leafy sprays bear tiny clusters of flowers each surrounded by five, bright red bracts which look like petals from winter to spring. Not frost hardy.

Beech · Fagus sylvatica
Fagaceae

Ovate, silky leaves with tassel-like male catkins, flowering in March and April, followed by the fruit which consists of two triangular nuts contained in a 4-lobed, woody husk, the outer surface covered with rough, spiny projections.

Fagus Latin name.
Beech ~ Prosperity

Magnolia
Magnoliaceae

This deciduous tree with it's beautiful, white, flushed mauve, cup-shaped flowers which are born in spring, carries cones of seed heads which split open when ripe to reveal the bright red seeds in the autumn. Oval leaves and plants native to Asia and North America

Magnolia.....after Pierre Magnol, a French botanist.

Lime - Linden - Tilia platyphyllos
Tiliaceae

Deciduous trees with alternate leaves, usually heart shaped. The fragrant flowers are carried in stalked clusters in spring/summer, followed by the fruit which is a small, round nut-like berry containing one or two seeds, in autumn. The flower stalk is winged half-way down and then the wings unite and continue as a bract and it seems as if the flowers (and seeds) arise from the centre of the bract. This arrangement is peculiar to this genus.

Tilia - Latin name
Lime or Linden tree --- conjugal love

Sycamore - Acer pseudoplatanus
Aceraceae

Tall, deciduous, spreading tree growing up to sixty feet in height. The dense heads of pendulous flowers turn to winged seedheads or 'aeroplanes' which spiral down to the ground. Sycamore is an ancient introduction and common everywhere.

Sycamore --- curiosity.

Common Burdock - Arctium pubens
Compositae

An upright, bushy plant flowering late summer to autumn. Round, spiny heads from 1. to 5" diameter topped with tubular, purple, disc-florets. When mature, the flower-heads form spiny balls or burs which attach themselves to animals or clothing and in this way get dispersed.

Burdock - Importunity - Touch me not.

135

December ~ from the Latin ~ the tenth month of the old Roman Calendar and the last in their year. The Saxons called it the 'Winter-monat' or winter month, or 'Haligmonath' or Holy month, because Christmas falls within this month

'Winter finds out what summer lays up'.

December

'Chill December brings the sleet
Blazing fire and Christmas treat'.

'They talk of Christmas so long that it comes'.

'He that survives a winter's
day escapes an enemy'.

'If it rains before mass on the first Sunday
in December, it will rain for a week'.

'December cold, with snow, is good for rye'.

'In December keep yourself warm and sleep'.

'It's a hard winter when one wolf eats another'.

'A green yule makes a fat kirk-yard'.

Now winter nights enlarge
The number of their hours,
And clouds their storms discharge
Upon the airy towers.
Let now the chimneys blaze
And cups o'erflow with wine;
Let well-tuned words amaze
With harmony divine.
Now yellow waxen lights
Shall wait on honey love,
While youthful revels, masques and
 courtly sights
Sleep's leaden spells remove.

This time does well dispense
With lover's long discourse;
Much speech has some defence,
Though beauty no remorse.
All do not all things well;
Some measures comely tread,
Some knotted riddles tell,
Some poems smoothly read.
The summer has his joys,
And winter his delights;
Though love and all his pleasures
 are but toys
They shorten tedious nights.
 Thomas Campion
 d. 1619.

Amaryllis ~ Amaryllis hippeastrum
Amaryllidaceae

A tall, striking plant with a large bulb. Leaves are strap-like and thick and the stout stem carries a head of brightly coloured, trumpet shaped blooms in colours ranging from white to pink and deep red. This plant is not hardy and should not be planted outside. It makes a good plant for house or conservatory.

Amaryllis.......... Pride

Azalea - Azalea obtusum -
Azalea japonica - Rhododendron obtusum
Ericaceae

A good houseplant although it can survive outdoors in sheltered areas. Open growth with dark green, oval to pointed leaves and very delicate flowers in white and soft pastel shades.

Azalea.......... Temperance

Ivy - Hedera helix - subs poetarum

This ivy can be found growing wild in North Africa, Turkey and parts of Greece, though it could well have been introduced by the Romans being associated with the cult of Bacchus.

mistletoe ~ Viscum album
Loranthaceae

An evergreen perennial subshrub living as a semiparasitic mainly on apple trees and occasionally conifers. The yellow-green leaves are sessile and opposite, leathery in texture and grow at the tips of the branched stems. The conspicuous fruit is an opaque, one seeded, white berry which is poisenous. The plant is native to Europe. In Germany the mistletoe was thought to be a magical plant which would bring death and the Celts held it as their most mystical, magical plant which would, amongst other things, heal illnesses and promote fertility. As the plant bears it's fruit in winter it was held as a symbol of the new year, and winter solstice.
'Mistletoe' from the Anglo Saxon 'mist tan' from 'mistel' or 'mist' = birdlime and 'tan' = twig - probably as a reference to the fact the seeds are spread by birds in their droppings.

Mistletoe.......... I surmount difficulties.

138

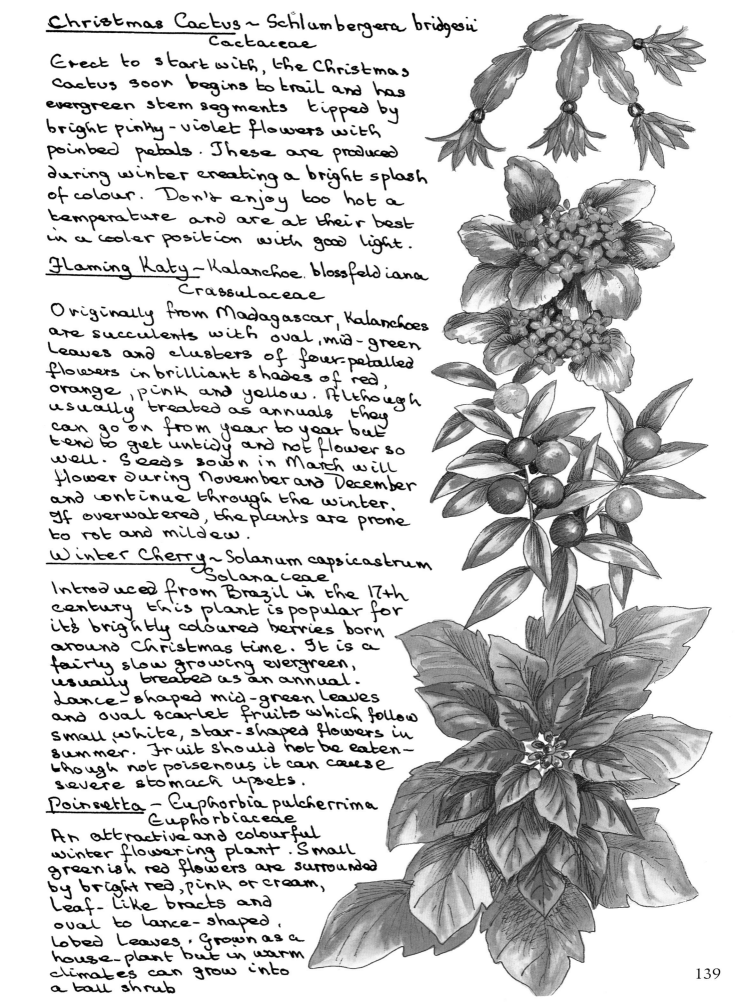

Christmas Cactus ~ Schlumbergera bridgesii
Cactaceae

Erect to start with, the Christmas Cactus soon begins to trail and has evergreen stem segments tipped by bright pinky-violet flowers with pointed petals. These are produced during winter creating a bright splash of colour. Don't enjoy too hot a temperature and are at their best in a cooler position with good light.

Flaming Katy ~ Kalanchoe blossfeldiana
Crassulaceae

Originally from Madagascar, Kalanchoes are succulents with oval, mid-green leaves and clusters of four-petalled flowers in brilliant shades of red, orange, pink and yellow. Although usually treated as annuals, they can go on from year to year but tend to get untidy and not flower so well. Seeds sown in March will flower during November and December and continue through the winter. If overwatered, the plants are prone to rot and mildew.

Winter Cherry ~ Solanum capsicastrum
Solanaceae

Introduced from Brazil in the 17th century this plant is popular for its brightly coloured berries born around Christmas time. It is a fairly slow growing evergreen, usually treated as an annual. Lance-shaped mid-green leaves and oval scarlet fruits which follow small, white, star-shaped flowers in summer. Fruit should not be eaten – though not poisonous it can cause severe stomach upsets.

Poinsetta ~ Euphorbia pulcherrima
Euphorbiaceae

An attractive and colourful winter flowering plant. Small greenish red flowers are surrounded by bright red, pink or cream, leaf-like bracts and oval to lance-shaped, lobed leaves. Grown as a house-plant but in warm climates can grow into a tall shrub

139

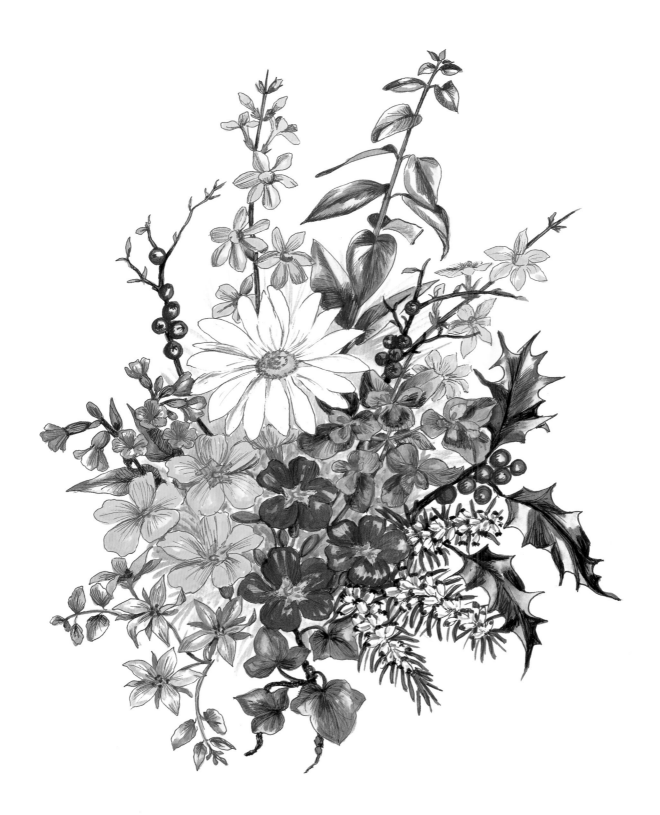

December

And in the frosty season, when the sun
Was set, and visible for many a mile
The cottage windows blazed through twilight gloom,
I heeded not their summons; happy time
It was indeed for all of us — for me
It was a time of rapture! Clear and loud
The village clock tolled six, — I wheeled about,
Proud and exulting like an untired horse
That cares not for his home. All shod with steel,
We hissed along the polished ice in games
Confederate, imitative of the chase
And woodland pleasures, — the resounding horn,
The pack loud chiming, and the hunted hare.
So through the darkness and the cold we flew,
And not a voice was idle; with the din
Smitten, the precipices rang aloud;
The leafless trees and every icy crag
Tinkled like iron; while far distant hills
Into the tumult sent an alien sound
Of melancholy not unnoticed, while the stars
Eastward were sparkling clear, and in the west
The orange sky of evening died away.
Not seldom from the uproar I retired
Into a silent bay, or sportively
Glanced sideway, leaving the tumultous throng,
To cut across the reflex of a star
That fled, and, flying still before me, gleamed
Upon the glassy plain; and oftentimes,
When we had given our bodies to the wind,
And all the shadowy banks on either side
Came sweeping through the darkness, spinning still
The rapid line of motion, then at once
Have I, reclining back upon my heels,
Stopped short; yet still the solitary cliffs
Wheeled by me — even as if the earth had rolled
With visible motion her diurnal round!
Behind me did they stretch in solemn train,
Feebler and feebler, and I stood and watched
Till all was tranquil as a dreamless sleep.

William Wordsworth

141

Christmas Eve

24th December

Christmas Eve is the traditional night for 'Father Christmas to arrive to fill the children's stockings with gifts. This was originally held on 6th December ~ St Nicholas' Day, but is now celebrated on 24th December in most countries, though some still acknowledge the 6th.

Father Christmas is also known as ~ St Nicholas ~ Sankt Nikolaus ~ Santa Claus or Santa Klaus.

The Holly or 'Holy-tree' is called Christ's-thorn in Germany and Scandinavia as it's berries are born at this time of the year and the branches used in Church decoration.

Christmas trees are reputed to stem back to the 'Scandinavian Ash', called 'Yggdrasil' ~ the tree of time, whose roots penetrate heaven. The modern Christmas tree was introduced to Britain from Germany in 1847, by Prince Albert, the husband of Queen Victoria.

The Ancient Egyptians took a branch of Palm with twelve leaves or shoots, to symbolise the 'completion of the year', at the winter solstice.

'If the sun shines through the apple trees on Christmas Day ~ The next autumn will have a good crop for display'.

'A green Christmas means a fat Churchyard'.

The weather was very foggy and cold over Christmas and we were glad of the big fires, which also included the Yule Log.

"Ever at Yuletide, when the great log flamed" In chimney corner, laugh and jest went round."

Aldrich Wyndham Towers
Stanza 5.

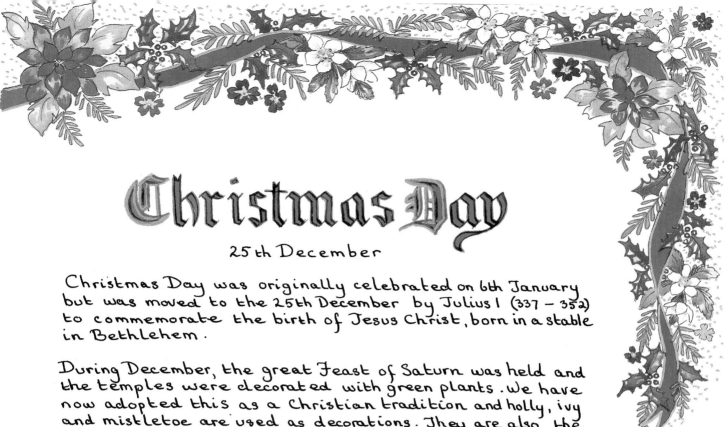

Christmas Day

25th December

Christmas Day was originally celebrated on 6th January but was moved to the 25th December by Julius I (337 – 352) to commemorate the birth of Jesus Christ, born in a stable in Bethlehem.

During December, the great Feast of Saturn was held and the temples were decorated with green plants. We have now adopted this as a Christian tradition and holly, ivy and mistletoe are used as decorations. They are also the symbol of everlasting life because they are evergreen.

Christmas carols are sung to commemorate the Nativity and the song of the Angels to the shepherds. In the past, the Bishops and Clergy would play games and sing carols on Christmas Day.

The 'Yule Log' was held as a great custom at one time, but with modern methods of heating it is not so well observed now. The log was often selected as early as Candlemas Day, 2nd February. It was stored carefully so that it would be really dry by Christmas. The log was carried into the house with great ceremony. In France the custom was for the youngest member of the family to pour wine over the log, while hymns were sung. The log was traditionally lit on Christmas Eve so that it would burn right over Christmas. The new log was lit using the remnants of the Yule Log from the previous year, which had been carefully preserved for the occasion. The log was then meant to smoulder through until twelfth night when the remaining ember would be taken off the fire and stored for the next year. If the Yule Log went out during the Christmas period, it was thought to be very bad luck and it was also believed the log would not burn if it had been touched by a young girl who had not washed her hands. In some areas, the prettiest girl in the room would sit on the log before it was placed on the fire. This was said to date back to the time when human sacrifices were cast upon the big Pagan bonfires.

143

Boxing Day

26th December

St Stephen's Day

'Gladly the boy with Christmas Box
in hand, Throughout the town his
devious route pursues, And of his
master's customers implores the yearly mite!'

The dole of the 'Christmas Box' or 'Box money', originated
in the early days of Christianity, when Churches placed
out boxes for the aid of charities. These boxes were
opened on Christmas Day and the contents distributed
the following day ~ 'Boxing Day' ~ It was also
customary for the head of the household to
give small sums of money to their servants to put
into the boxes before mass on Christmas Day. A
small gratuity would be given to employees on
Boxing Day and later, apprentices carried round a
box to their master's customers for small gratuities.
However, since 1836, this custom has largly died out.

At one time, farmers would bleed their livestock on
Boxing Day as they believed it would be good for
the animals health in the coming year.

Boxing Day is traditionally a great hunting and
sporting Day.

Very cold and frosty still. The annual Boxing Day
meet of the Albrighton Hunt met for their
'stirrup cup' in front of the local Hotel. Always
very colourful with the riders smartly dressed in
'pink' or black, the horses hooves ringing on the
cobbled street and the hounds milling around,
pink tongues and eagerly sniffing noses, their tails
wagging frantically with excitement for the chase.
No hunting today though as the ground was too frozen.

'A windy St Stephen's Day is bad for next years harvest

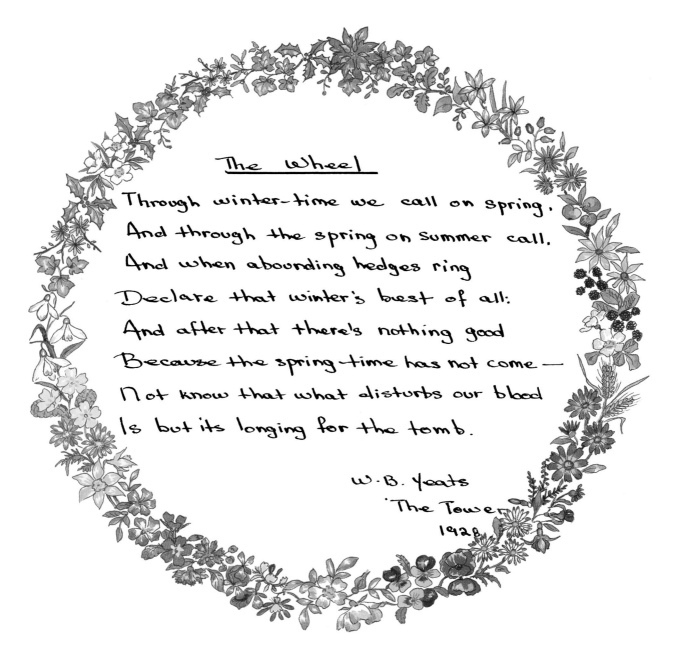

The Wheel

Through winter-time we call on spring,
And through the spring on summer call,
And when abounding hedges ring
Declare that winter's best of all:
And after that there's nothing good
Because the spring-time has not come —
Not know that what disturbs our blood
Is but its longing for the tomb.

W.B. Yeats
'The Tower'
1928

Bibliography

Barker, Cicely M., *The Book of the Flower Fairies*. London: Frederick Warne and Co., 1991.

Blamey, Marjorie, and Christopher Grey-Wilson, *The Illustrated Flora of Britain and Northern Europe*. London: Hodder and Stoughton, 1989.

Boland, Maureen and Bridget, *Old Wives Lore for Gardeners*. London: The Bodley Head, 1956.

Brewer, *The Dictionary of Phrase and Fable*. New York: Avenel Books.

Brickell, Christopher, editor-in-chief, *The Royal Horticultural Society—Gardener's Encyclopaedia of Plants and Flowers*. London: Dorling Kindersley, 1989.

Crossland, John R., and J. M. Parish, editors, *Britain's Wonderland of Nature*. London: Collins.

Ferguson, James, *Emmerdale Farm Book of Country Lore*. London: Hamlyn Publishing.

Fitter, R. S. R., and R. A. Richardson, *Collins Pocket Guide to British Birds*. London: Collins.

Johns, C. A., BA, FLS, *Flowers of the Field*. Edited by R. A. Blakelock. London: Routledge and Kegan Paul Ltd.

Joseph, Michael, *The Language of Flowers*. London: Running Press Book Publishers, 1991.

Keith, Stuart, and John Gooders, *Collins Bird Guide*. London: Collins.

Longman, David, *The Care of House Plants*. Eurobook Ltd.

Macfadyen, David, *A Cottage Flora*. Illustrated by Peter Morter. Devizes: Selecta Books Ltd.

Martin, W. Keble, MA, FLS, *The Concise British Flora in Colour*. London: Ebury Press and Michael Joseph.

Pearson, C. E., OBE, NOA, editor, *Complete Gardening*. London: Treasure Press.

Phelps, Edward and Geoffrey Summerfield, *The Four Seasons*. Oxford: Oxford University Press.

Phillips, Roger, *Trees in Britain, Europe and North America*. London: Pan Books Ltd., 1978.

Phillips, Roger, *Mushrooms and other Fungi of Great Britain and Europe*. London: Pan Books Ltd., 1981.

Phillips, Roger, and Martin Rix, *Perennials—Volumes 1 and 2*. London: Pan Books Ltd., 1991.

Phillips, Roger, and Martin Rix, *Shrubs*. London: Pan Books, Ltd., 1989.

Pickles, Sheila, editor, *The Language of Flowers*. London: Penhaligon, 1994

Polunin, Oleg, *The Concise Flowers of Europe*. London: Oxford University Press, 1987.

Proudley, Brian and Valerie, *Blandford Colour Series: Fuchsiasin Colour*. London: Blandford Press.

Stodola, Jiri, and Jan Volak, *The Illustrated Book of Herbs*. Edited by Sarah Bunney. London: Octopus Books.

The Wonder World of Nature. London: Collins.

Whalley, Paul, *Hamlyn Nature Series—Butterflies of Britain and Europe*. Hamlyn Publishing Group, 1988.

Index

149

SEASONS IN A COUNTRY GARDEN

All art and calligraphy by Freda Cox.
All imagery elesctronically scanned from original art.
Composed by Fulcrum Publishing in Adobe Hiroshige.
Printed by Sung In Printing, Seoul, Korea.
Text paper is 150 gsm art matte coat.
Endsheet paper is 150 gsm Wood free
Bound by Sung In Printing, Seoul Korea,
in Holliston Traditional Kingston cloth, smythe-sewn on three millimeter binder's board,
with head and foot bands, stamped in gold foil.